W. Eugene Smith

HIS PHOTOGRAPHS AND NOTES

AFTERWORD BY

LINCOLN KIRSTEIN

AN APERTURE MONOGRAPH

Aperture Foundation, Inc., publishes a periodical,
books, and portfolios of fine photography to
communicate with serious photographers and
creative people everywhere.
A complete catalog is available upon request.
Address: 20 East 23rd Street, New York,
New York, 10010.

Stonetone negatives by Rapoport Printing
Corporation, New York. Printed and bound
by Everbest Printing Co., Ltd., Hong Kong.

1918: Born December 30, Wichita, Kansas.

1924-1930: Attended Catholic parochial school; fascinated by subjects of history and biography from age of eight.

1930-1935: Through junior year, attended Catholic high school. In early grades, photography first employed to aid in drawing maps for class assignments. At fourteen, developed intense interest in all aspects of aviation, including aircraft design and engineering; use of camera for aeronautical studies and on visits to Wichita airport. Rapidly, photography emerged as dominant concern. Received initial advice and encouragement assisting Wichita newsphotographer, Frank Noel, eventual Pulitzer Prize recipient, on assignments.

1935-1936: During junior year and following transfer to public school for final high school year, began to work for local newspapers, the *Wichita Eagle* and *Wichita Beacon*. Photographed sports and aviation events; environmental devastation resultant from windstorms, drought, and grasshopper invasions during Dust Bowl period. Initially realized capacity for intuitive sense of timing and enthusiasm for photographing actual events, but later destroyed this early work, feeling that it lacked technical control and interpretive insight.

1936: Suicide of father following several years of drought disaster, business failure, and despair. Distorted sensationalism of local newspaper reportage following father's death provoked bitter hatred of dishonest journalistic habits. Considered abandoning intention to continue work in photographic journalism; convinced by newspaper colleague that "honesty is not of a profession, but within the individual and what he brings to his work." Following graduation from high school entered University of Notre Dame in the fall on special photography scholarship.

1937: Hackneyed demands on photography prompted searching restlessness. Left the University. Upon publication of *Life* magazine, turned to challenge of New York. Joined staff of *Newsweek*.

1938: Realized that use of the miniature camera provided greater freedom for "seeing." In spring, fired by *Newsweek* for making 2¼ x 2¼ exposures on an assignment after specific orders not to use miniature cameras. Following difficult period of unemployment, freelanced, joined Black Star Agency; first work in *Life, Colliers, American Magazine, Harper's Bazaar, The New York Times*. Used miniature cameras, concentrating on techniques and use of artificial light, particularly multiple-flash.

1939: Signed retainer contract with *Life* magazine. Discovered responsiveness to "wonderment world of music" which became and continued as one of several major influences in development of views on ethics, professional integrity, and the creative process. Began collection which in time includes over 17,000 phonograph records.

1941: Interested in pursuit of individual directions and increasingly dissatisfied with routine of *Life* assignments, resigned contract though warned career would be jeopardized and there would be no further opportunities to work for the magazine.

1942: Freelanced, choosing assignments; later felt freedom misused because of creative immaturity; that photographs made had "great depth of field, very little depth of feeling." In later repudiation of this period of work, acknowledged that subsequent photography was a logical development of the past and not representative of a drastic shift in values. Self-injured accidentally by dynamite-charge explosion while making photograph of simulated battle conditions for *Parade* magazine; suffered concussion and impairment of hearing, rendering him physically disqualified for military service. Events of World War II began to completely absorb his attention. Invited to submit application to join Edward Steichen's Naval Aviation photographic unit. In spite of official appeals, disqualified several times on grounds of physical examination and insufficient college education; final review by committee of three Admirals stated: "Although he appears to be a genius in his field, he does not measure up to the standards of the United States Navy." Persisted in efforts to become a photographic correspondent in the war, particularly to develop a picture story about an aircraft carrier.

1942-1945: Served as war correspondent briefly in Atlantic theater on special assignments for several publications. Joined staff of Ziff-Davis Publishing Company; assigned to aircraft carrier *Independence*, covered second raid on Wake Island. In November, 1943, transferred to carrier *Bunker Hill*, which attacked Rabaul and was in turn attacked by Japanese bombing force; photographic missions during grisly battles on Tarawa, Naru Island, and Kavieng, New Ireland, during Christmas holidays. Flew over Marianas to take photographs of airfields being destroyed by carrier planes and of torpedo wakes in water. Had flown on sixteen combat missions when returned to San Francisco in March, 1944 On return to New York, discovered censors had prevented release of about half of photographs completed. Resigned staff of Ziff-Davis

Publishing Company. In May, 1944, joined *Life* to continue work in Pacific theater. Secondary equipment for new assignment included portable phonograph and 160 records: Wagner, a Sibelius symphony, twenty-three operas, Josh White's "Southern Exposure," some Burl Ives, Miff Mole's "St. Louis Blues" and "Peg o' My Heart," a number of Russian songs, Beethoven, Bach, Mozart, Max Bruch, "Lili Marlene," and Lena Horne's "Mad About the Boy." First assignment for *Life* was invasion of Saipan, June, 1944; covered invasion of Guam in July. Returned to Saipan in September. From Saipan, flown to Marshall Islands to rejoin task force scheduled for invasion of Peleliu. On orders, carrier altered course toward Philippines; reached Leyte end of October. Weakened by recurrent attacks of dengue fever, flown to Pearl Harbor; back to States for Thanksgiving. Day after Christmas, 1944, returned to Pearl Harbor; rejoined *Bunker Hill* for service as only photographer allowed on scheduled raids on Tokyo in February, 1945. Following Tokyo raids, to Iwo Jima for coverage of amphibious assault to capture island. From Iwo Jima to Guam for several days, back to Iwo until it was secured, returned to Guam at end of March. From Guam "hitchhiked" on destroyers, cruisers, and other vessels across 1,500 miles of the Pacific to cover invasion of Okinawa. Boarded one of the "alligators" in the first invasion wave on Easter Sunday, April 1. During thirteenth campaign on May 22, 1945, severely wounded by shell fire while accompanying foot-soldier during dangerous combat maneuvers to take photographs for story to be titled "24 Hours With Infantryman Terry Moore." Extensive field surgery required for multiple head, chest, and back injuries; evacuated to Guam. On June 17, returned to New York. Of photographs during involvement in World War II, wrote: "I would that my photographs might be, not the coverage of a news event, but an indictment of war—the brutal corrupting viciousness of its doing to the minds and bodies of men; and, that my photographs might be a powerful emotional catalyst to the reasoning which would help this vile and criminal stupidity from beginning again." Considered the photographs to be failures.

1945-1947: Continued medical treatment and operations for repair of injuries. Near the close of two years of painful convalescence, exposed first negative since wounding on Okinawa; a photograph which became internationally renowned and concluded exhibition, "The Family of Man" (1955), organized by Edward Steichen for The Museum of Modern Art: of two children on a path in the woods, approaching a clearing roughly arched by trees and illuminated by a bright shower of light. Photograph associated with title, "The Walk to Paradise Garden," based on

similar title of musical work by British composer, Frederick Delius.

1947-1954: Returned to nearly full-time work schedule for *Life* in 1947. Informed that ability as photographer would have to be proved again. Turbulent but productively creative years evolved despite difficulties of war injuries and hospitalization for several months in 1950. Created major photographic essays during period, including: "Folk Singers" (1947), "Trial by Jury" (1948), "Country Doctor" (1948), "Hard Times on Broadway" (1949), "Life Without Germs" (1949), "Recording Artists" (1951), "Spanish Village" (1951), "Nurse Midwife" (1951), "Chaplin at Work" (1952), "The Reign of Chemistry" (1953), "My Daughter Juanita" (1953), "A Man of Mercy" (1954). Resignation from *Life* magazine ". . . quietly and regretfully contemplated, quietly and grimly utilized in an effort—a futile effort—to gain or force a different handling of the Dr. Albert Schweitzer essay ('Man of Mercy')." Contrary to legend, resignation submitted prior to actual layout of essay when *Life* editors announced abrupt schedule for publication of essay within limited number of pages subject to restrictive closing deadlines.

1955: Resignation from contract with *Life* magazine became effective. On the event, wrote: ". . . superficiality to me is untruth when it is of reportorial stature. It is a grievous dishonesty when it is the mark of any important subject. . . . I do not accuse them of a lack of integrity, for as they relate within the concept framework of their magazine factory, as they relate to its dominant precedents, they are apparently sincere and honest men. However, I cannot accept many of the conditions common within journalism without tremendous self-dishonesty and without it being a grave breach of the responsibilities, the moral obligations within journalism, as I have determined them for myself." Joined Magnum Photos. Began most ambitious effort to date in medium of photographic essay, study of the city of Pittsburgh. Predominantly self-financed, hoped to establish precedent of photographer's control over usage of work, text, and layout; to encourage magazines toward realization of greater flexibility in approach to photographic essay.

1956: Continued work on Pittsburgh essay assisted by a fellowship awarded by John Simon Guggenheim Memorial Foundation. First major work in color begun when commissioned by American Institute of Architects to photograph contemporary American architecture for A.I.A. Centennial exhibition to commemorate one hundred years of American architecture.

1957: Completed work on A.I.A. color project, series of ten illuminated transparencies up to eighteen feet

in length, entitled "Ten Buildings in America's Future," exhibited at National Gallery of Art, Washington, D.C. Received second Guggenheim Fellowship, enabling continuation of work on Pittsburgh essay. Established studio work space in Sixth Avenue loft, New York; began new project concerned with photographing at seasonal intervals things, people, and events—"rhythms of the city"—seen from loft window and the loft building itself and its life within seen from outside: "a most intriguing place and project . . . I can see photographing it through the years, by day and by night, watching the lines of its character alter." Dire personal difficulties related to health and financial stability; nonetheless realized "a wonderful sense of inner expansion to see and to understand." Intensified creative period; photographing, writing, experimental layouts for essays. Involved in a seven day week, averaging twenty hours a working day, often engaged in the studio for as much as seventy hours at a time: "the hungry artist has worse things than success to hang him up."

1958: Continued loft series, now called "As from my window I sometimes glance. . . ." Part of series published by *Life* under title "Drama Beneath a City Window." Essay selected by United States Information Agency for publication and distribution to Russia; without photographer's knowledge U.S.I.A. airbrushed a casually included police car from photograph of street scene. Began teaching course entitled "Photography Made Difficult" at New School for Social Research. Photographed "Atoms for Peace Conference" in Geneva. Recognized as one of "The World's 10 Greatest Photographers," result of international poll by *Popular Photography* magazine. Began photographic essay on Haitian mental clinic; series of progress visits during planning, building, first treatments of clinic designed to administer drug therapy to patients. Began monumental book, *The Walk to Paradise Garden*, to become extensive essay drawn from entirety of work: "A statement of my philosophies and discriminations . . . letting truth be my prejudice . . . dedicated to those not taking the past in proof against the future." Photographic essays for magazines, including *Pageant* and *Sports Illustrated*. Resigned from Magnum Photos. Appeared with Dan Weiner on television program, "The Press and the People," produced by WGBH-TV, Boston. Thirty-eight pages of Pittsburgh essay with text under title, "Labyrinthian Walk," published *1959 Photography Annual*.

1959: Received award plaque, Third Annual Photojournalism Conference, American Society of Magazine Photographers, University of Miami, Florida. Presented Cliff Edom Founders Award plaque by Kappa Alpha Mu Photography Fraternity. Photographic essay on Haitian mental clinic basically completed; unpublished in entirety to date. Health badly deteriorated. Carole Thomas, an art student from Cooper Union, entered life: "She assisted me as a 'human photostat machine,' sketching over five hundred photographs to size and in detail for the first dummy of *The Walk to Paradise Garden*. I grew to love her deeply and to admire her abilities as a graphic artist and editor, her eventual excellence as a photographer. She was a beautiful strength in my life for nearly ten years."

1960: Private classes in photographic journalism. Beginning of decade of conferences and exhibitions including: University of Oregon, Rochester Institute of Technology, Society for Photographic Education, Expo 67 Symposium; Heliography Gallery, Rochester Institute of Technology, New York University, The Museum of Modern Art, George Eastman House with national circulation; "Photography at Mid-Century" (George Eastman House), "The Photographic Essay" (The Museum of Modern Art), "The Camera As Witness" (Expo 67), "Photokina," "Festival of the Arts" (White House, Washington, D.C.). Works purchased by George Eastman House, The Museum of Modern Art, The Art Institute of Chicago.

1961: Completed dummy for book, *The Walk to Paradise Garden*. Commissioned by Japanese industrial firm, Hitachi Limited, to photograph extensive operations. Began cherished year in Japan. Booklet, *Hitachi Reminder*, published in Tokyo.

1962: Continued working in Japan; several portfolios published in Japanese magazines. Worked on book to be produced by Hitachi Limited and distributed in United States. Returned to United States in September.

1963-1964: Contributed to *Life* magazine photographic essay, "Colossus of the Orient," based on work for Hitachi Limited. Hitachi sponsored book, *A Chapter of Image*, distributed in United States; conceived, photographed, and written with assistance from Carole Thomas. Appointed to President's Committee on Photography.

1965: With Carole Thomas worked on development of *Sensorium*, magazine of photography and other arts of communication; first issue unpublished when financial backing withdrawn.

1966-1969: Became Special Editor, medical reportage, *Visual Medicine* magazine; position terminated when publication sold. Commissioned by Hospital for Special Surgery, New York, to photograph its services. Associated with faculty, School of Visual Arts, New York. Health improved. Received rare honor of third Guggenheim Fellowship.

In appreciation of Carole, who—as in so many things—
was essential to the completion of this book

With gratitude to the John Simon Guggenheim Memorial
Foundation for the assistance given me on three occasions.

In this presentation of my work the photographs are not arranged
according to strict chronology. The approach is episodic in form;
essentially, a series of portfolios. In the first are five photographs which
I believe have a spiritual kinship. A World War II portfolio follows. Next,
another portfolio of diverse subjects, free-flowing. And so on.

Photographs related to the photographic-essay are presented here as
individual works, as excerpts from the essays, presented in portfolio
form. There is no intention to offer a thorough journalistic approach
to the subjects involved.

I hope that this arrangement of my work will suggest why I have found
photography so worth the involvement.

 W. E. S.

W. EUGENE SMITH

I doubt the existence of any perfection, although I am for trying the rise to this the impossible and would take measure from such failure rather than from the convenience of a safe but mundane success. (I do not deplore success.) I would experience ever deeper, and endeavor to give out from this experience. My photographs at best hold only a small strength, but through them I would suggest and criticize and illuminate and try to give compassionate understanding. And through the passion given into my photographs (no matter how quiet) I would call out for a spiritualization that would create strength and healing and purpose, as teacher and surgeon and entertainer, and would give comment upon man's place and preservation within this new age—a terrible and exciting age. And with passion. Passion, yes, as passion is in all great searches and is necessary to all creative endeavors—whether of statesman, or scientist, or artist, or freedom, or devil—and Don Juan may have been without passion, for sex and sentiment and violence can very much be without passion. Question this? Take note of the values around you, everywhere thrust upon you—and wade awhile, with this question in thought, through publications and publications from cover to cover.

—1958

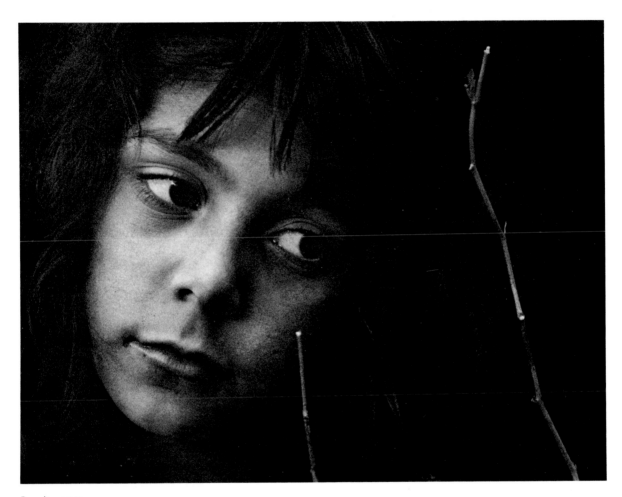

Juanita, 1953

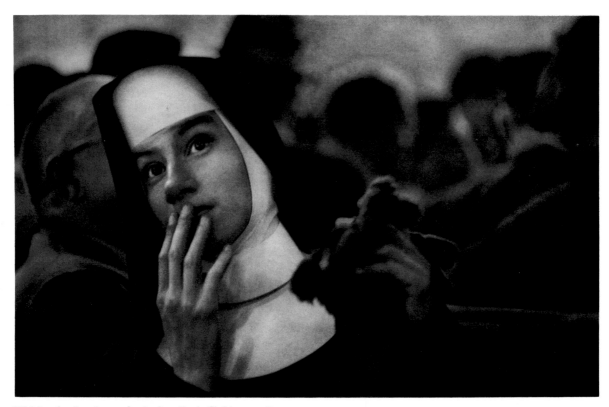
Waiting for Survivors: the Andrea Doria Sinking, 1956

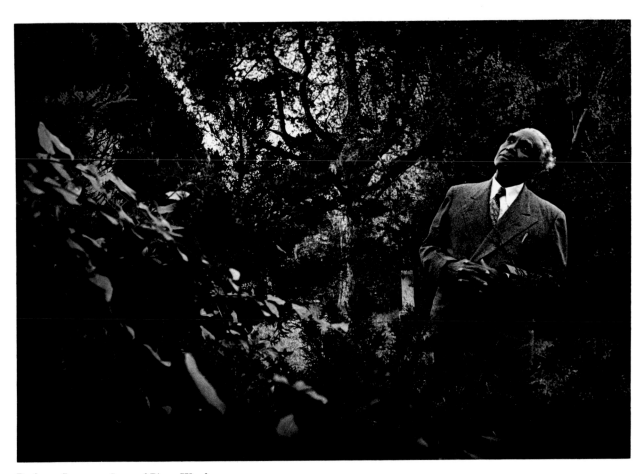

Professor Laurence Jones of Piney Woods, 1955

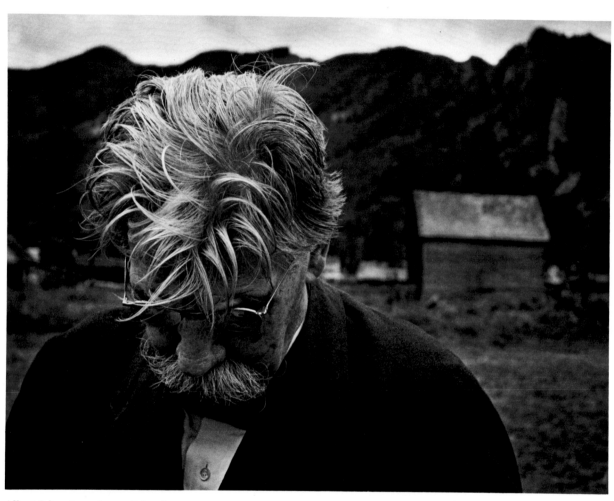

Albert Schweitzer, Aspen, Colorado, 1949

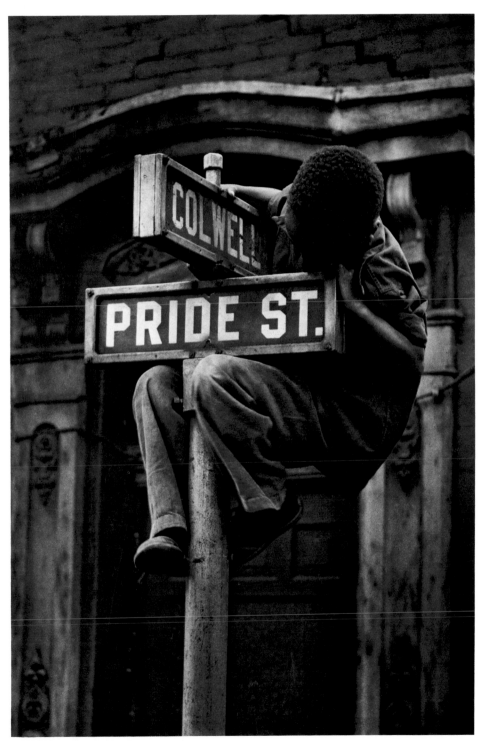

Pittsburgh, 1955

WORLD WAR II . . . and each time I pressed the shutter release it was a shouted condemnation hurled with the hope that the pictures might survive through the years, with the hope that they might echo through the minds of men in the future—causing them caution and remembrance and realization.

Know that these people of the pictures were my family—no matter how often they reflected the tortured features of another race. Accident of birth, accident of place—the bloody, dying child I held momentarily while the life-fluid seeped through my shirt and burned my heart—that child was my child.

From a letter—Saipan, 1944

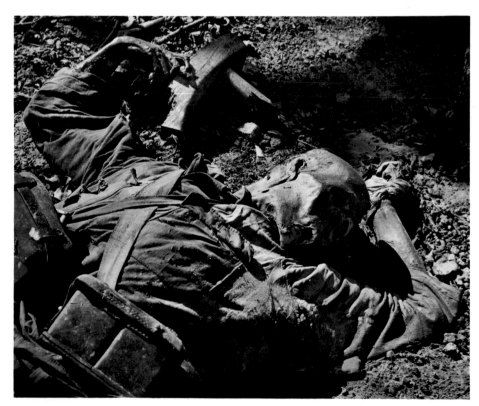

Iwo Jima, 1945

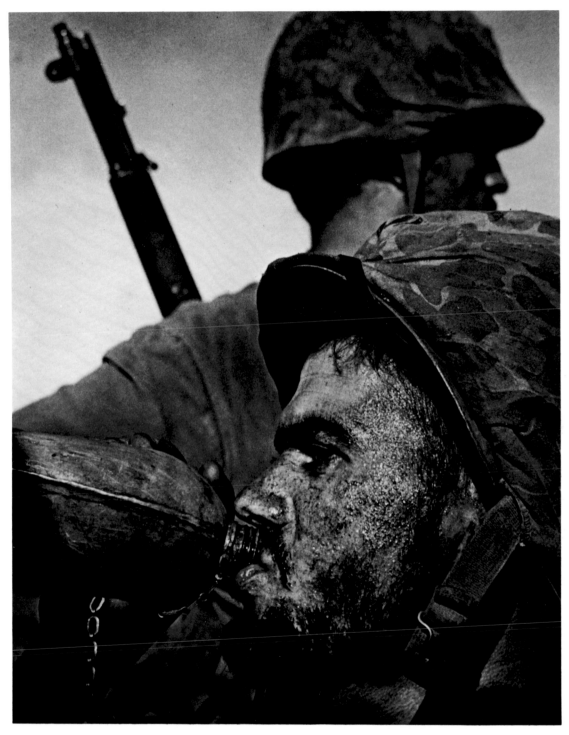

Saipan, 1944

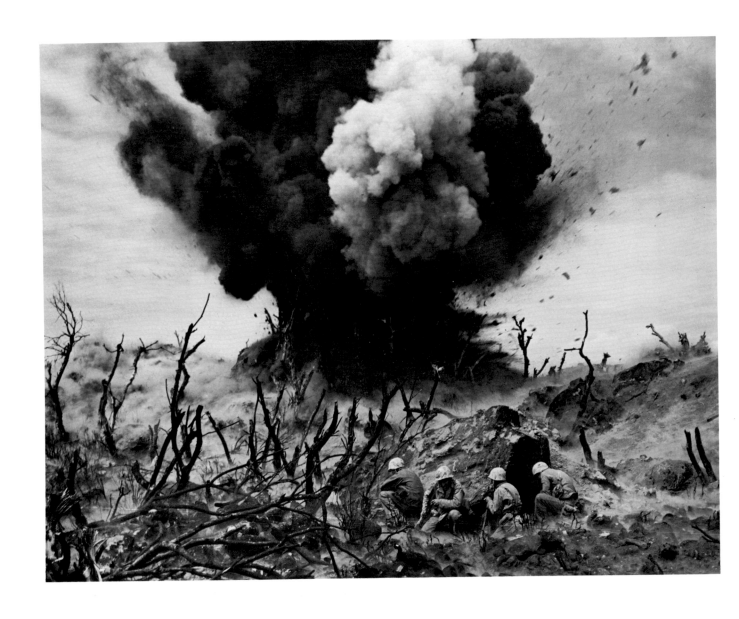

The caption sheet was marked with embittered words: "Sticks and stones, bits of human bones . . . a blasting out on Iwo Jima."

. . . the *Bunker Hill* under attack by a hundred or more Rabaul-based planes, shortly after a communique from General MacArthur that Rabaul was "no more." The carrier was lucky that day. The crew swore truth to a legend that Captain Ballantine—the respected "Skipper himself"—at the gut moment, grabbed the wheel and careened the ship to safety between two bombs which just missed the ship on one side and two more which burst equally close on the other. Later, the luck of the *Bunker Hill* changed drastically.

Armistice Day, 1943

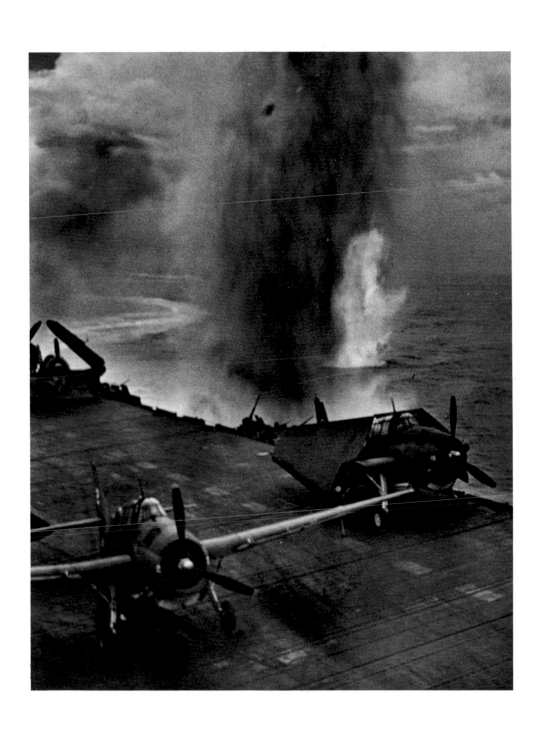

A terrified mother and child wheel in bewilderment behind a shell-broken tree—tattered, filthy, starving, their bodies scratched and insect-bitten.

Trapped in a cave, they were flushed from it by threats, by promises, by grenades and smoke bombs. They burst out, stumbling, dazed, choking and nearly blind from fumes, past the still-warm corpses of a man and a boy. Trying to escape when there was no escape.

—Saipan, 1944

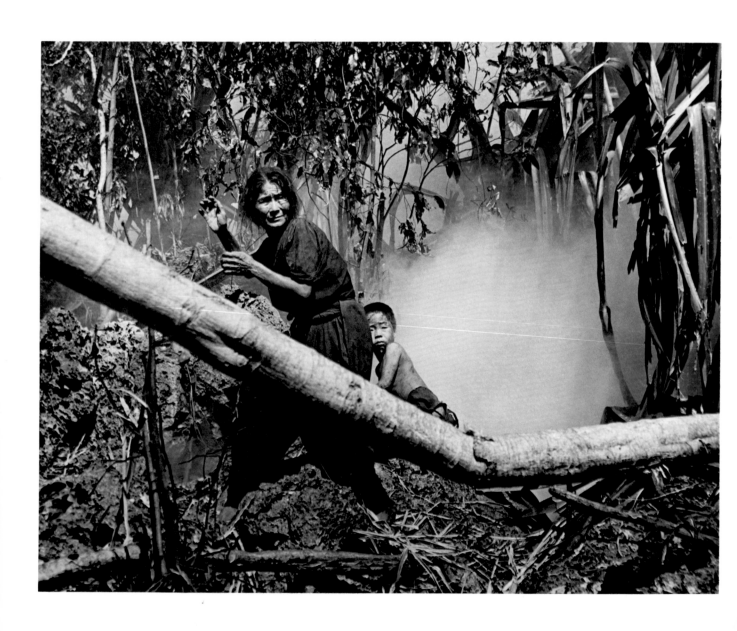

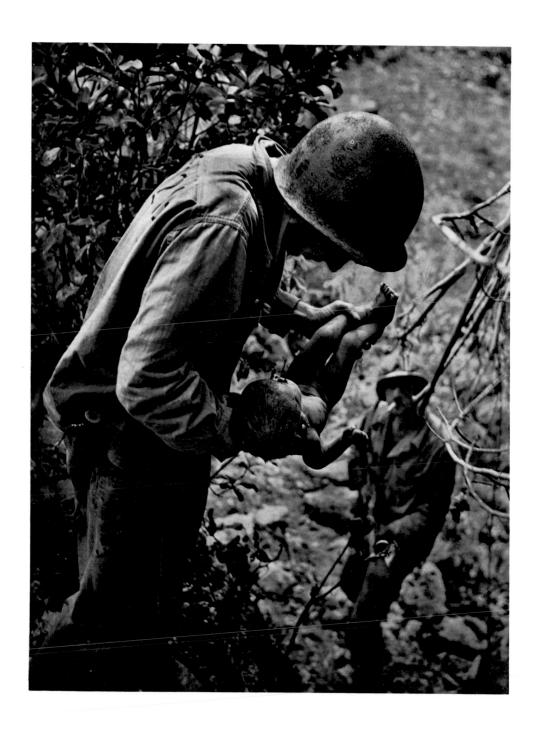

A baby was found with its head under a rock. Its head was lopsided and its
eyes were masses of pus. Unfortunately, it was alive. We hoped that it would die.
—*Saipan*, 1944

Whether he negotiated before as hero or coward, his one life has been used up by his country, and he is shunted into the sea. A few brief words, a loud splash, and war goes on.

—1943

He writhed in his terrible pain. He could not be given morphine because of his head wound. He put his hands together and began to pray. Almost immediately he became quiet—the prayer seemed to give him comfort.
—*Okinawa, April* 19, 1945

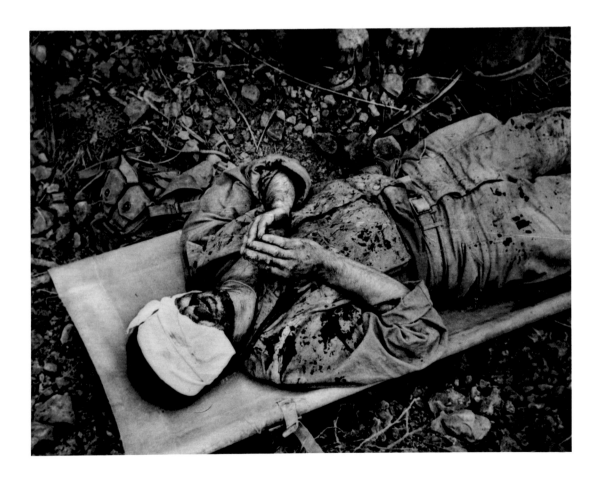

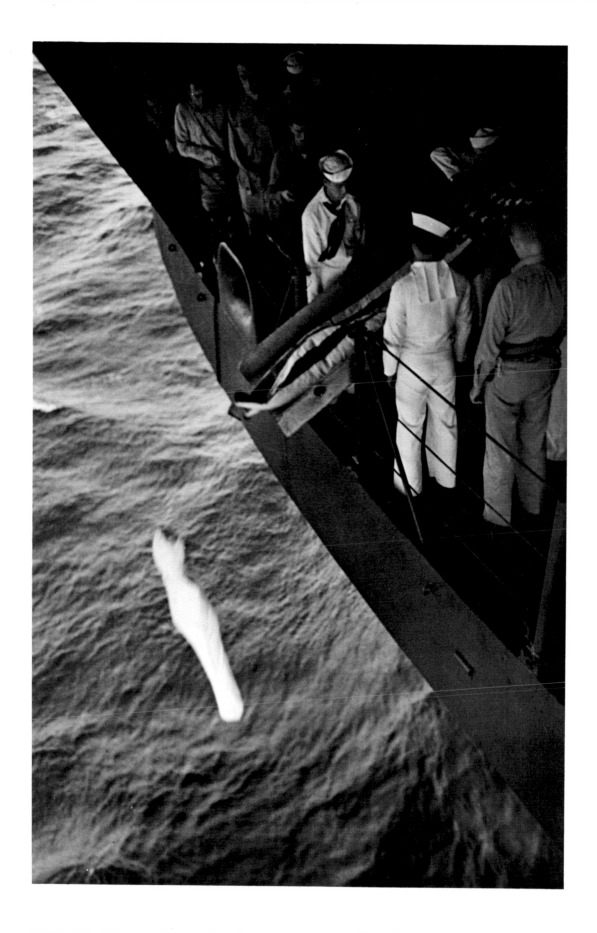

THE WALK TO PARADISE GARDEN . . . The children in the photograph are my children, and on the day I made this photographic effort, I was not sure I would be capable of ever photographing again.

There had been the war—now it seems a long time ago, that war called World, volume II—and during my 13th Pacific invasion shell fragments ended my photographic coverage of it. Two painful, helpless years followed my multiple wounding, during which time I had to stifle my restless spirit into a state of impassive, non-creative suspension, while the doctors by their many operations slowly tried to repair me. . . . But now, this day, I would endeavor to refute two years of negation. On this day, for the first time since my injuries, I would try again to make the camera work for me, would try to force my body to control the mechanics of the camera; and, as well, I would try to command my creative spirit out of its exile.

Urgently, something compelled that this first photograph must not be a failure—pray God that I could so much as physically force a roll of film into the camera! I was determined that this first photograph must sing of more than being a technical accomplishment. Determined that it would speak of a gentle moment of spirited purity in contrast to the depraved savagery I had raged against with my war photographs—my last photographs. I was almost desperate in this determination, in my insistence that for some reason this first exposure must have a special quality. I have never quite understood why it had to be thus, why it had to be the first and not the second; why, if not accomplished today, it could not be accomplished next week; yet that day I challenged myself to do it, against my nerves, against my reason. . . .

Whatever the reason—probably more complex than one—I felt, without labeling it as such, that it was to be a day of spiritual decision. . . .

Still, and regardless of the conflict that raged within me, there was no change in my determination, and of my intentions for that first photograph. These woods with these children prancing through them in happiness . . .

. . . as against war photographs I had made of a terrified mother and her child wheeling in bewilderment behind a shell-broken tree . . .

—1946

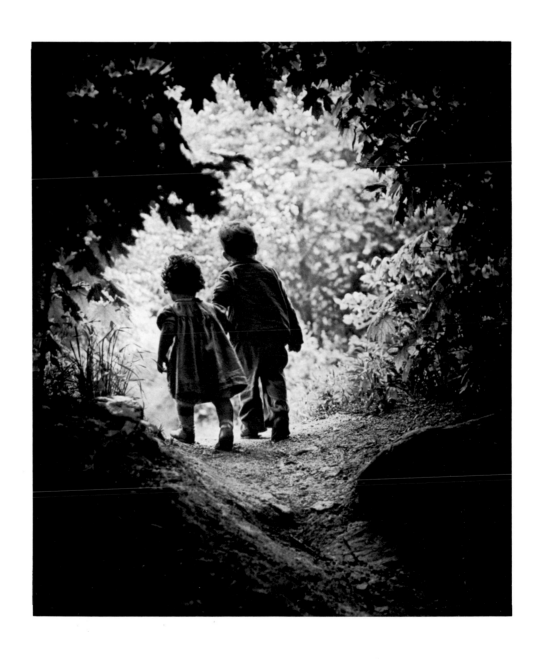

TRANSITION, FROM THERE TO NOW, AND INTO TOMORROW . . . to remind myself that man need not take the past as proof against the future . . . to ever be in escort of a questing mind—the mind a launching pad—the mind a sensorium, a computer of perceptions, awake to the living that is everywhere, the images to be found. Aware to think in many lights; aware, too, that shadows also cast realities . . . remaining, always, curious toward the ways of others, ready to appreciate the differences, wary of diverting splinters such as knick-knack thinking . . . and my cameras as note takers for my mind, so I may place evidence before others . . . telling them why I am seldom bored.

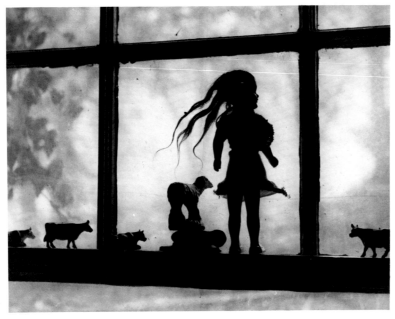

Window on a Foggy Morning, 1954

Fantasy Portrait of a Friend, 1959

Cello Case, 1956

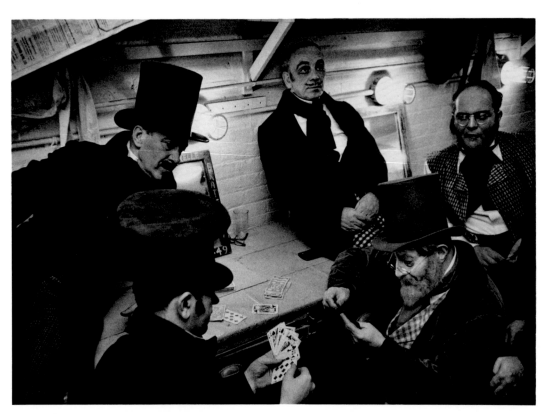

Dressing Room, Metropolitan Opera, 1953

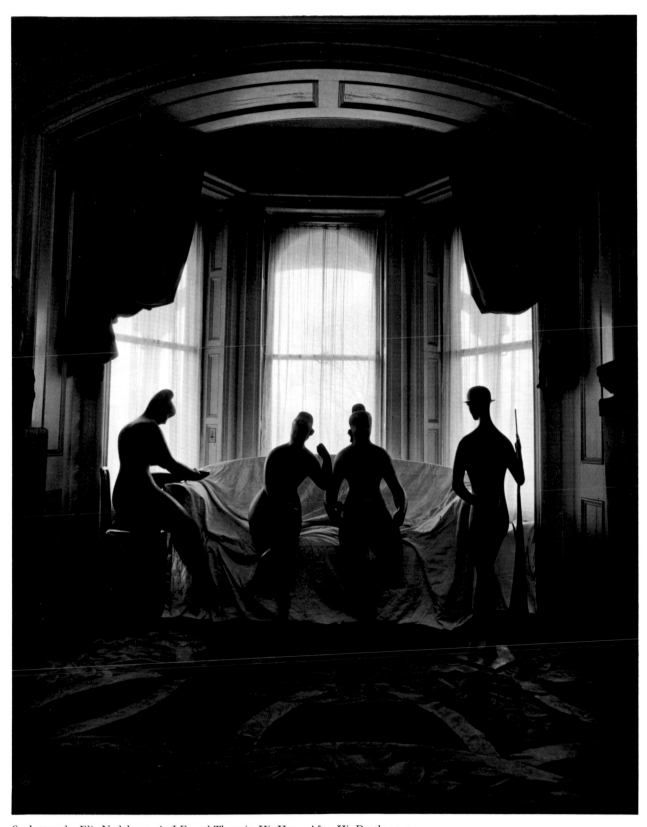

Sculptures by Elie Nadelman, As I Found Them in His Home After His Death, 1949

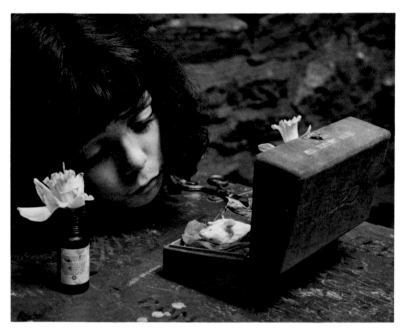

Death of Gus-Gus, 1953

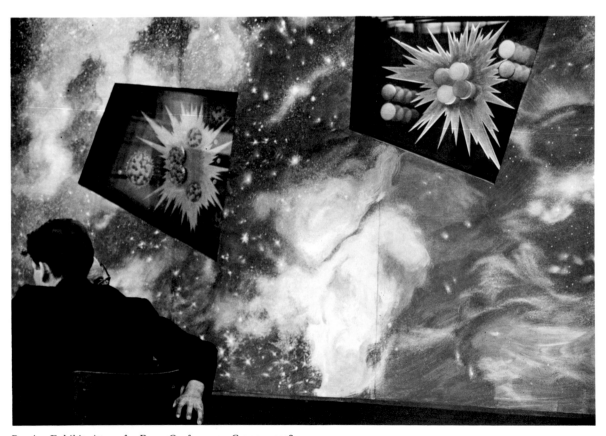

Russian Exhibit, Atoms for Peace Conference—Geneva, 1958

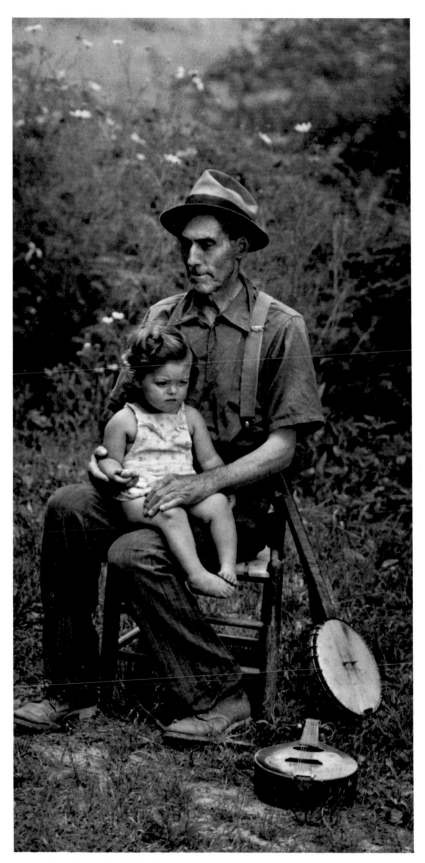

In the Mountains, North Carolina, 1947

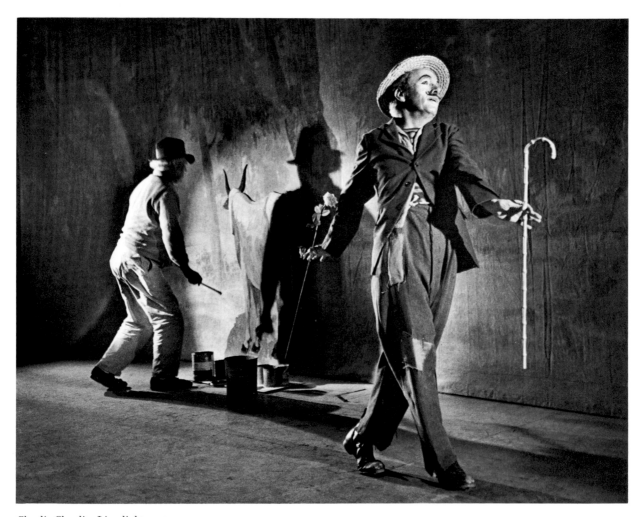

Charlie Chaplin, Limelight, 1952

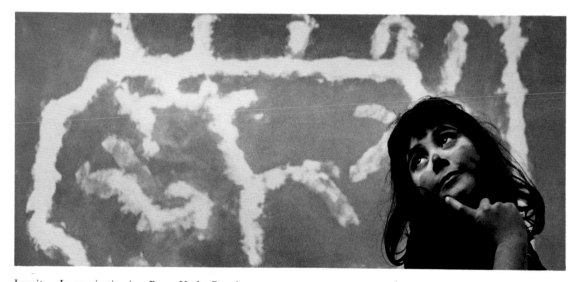

Juanita—Improvisation in a Room Under Repair, 1953

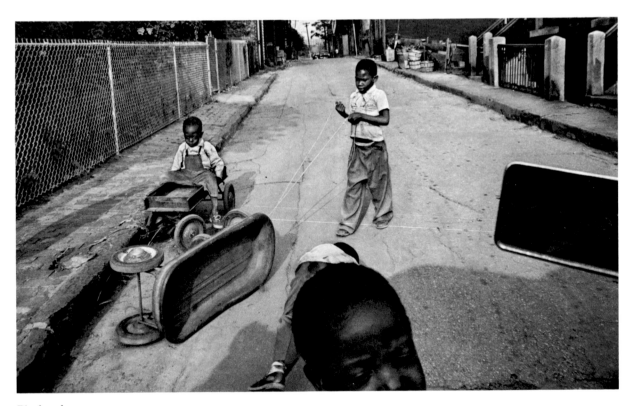

Pittsburgh, 1955

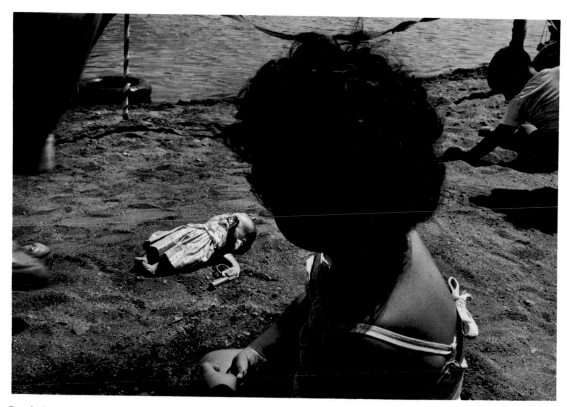

Beach Scene, 1958

ANTI-VIETNAM-WAR PROTEST, CENTRAL PARK, APRIL 15, 1967

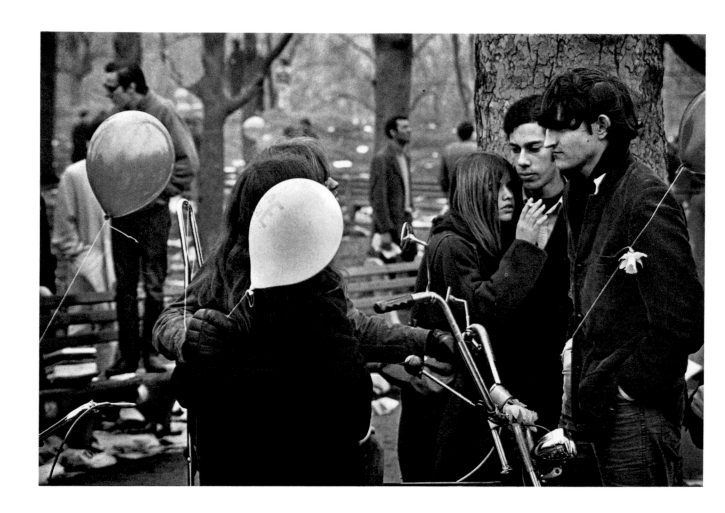

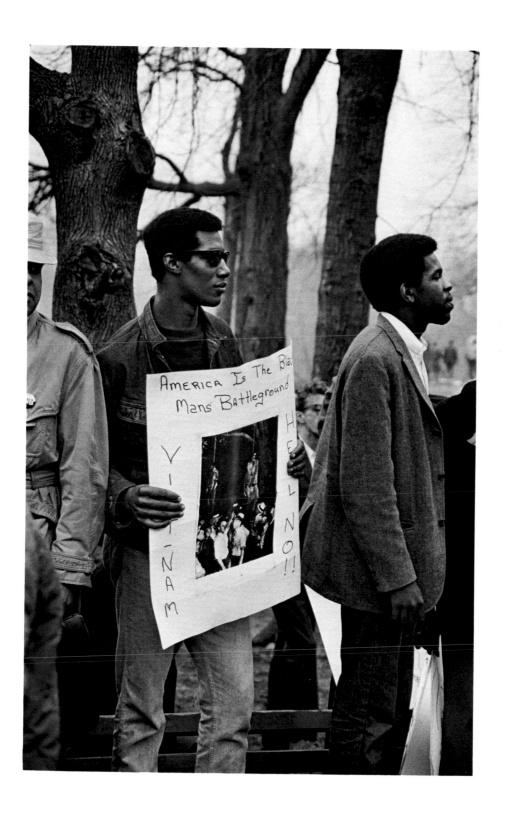

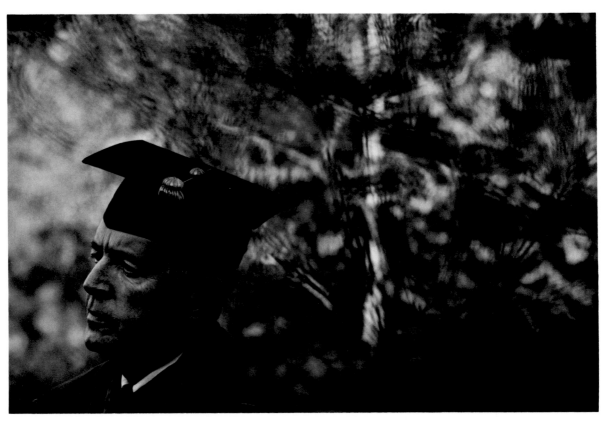

Dr. Kraushaar, President of Goucher College, 1967

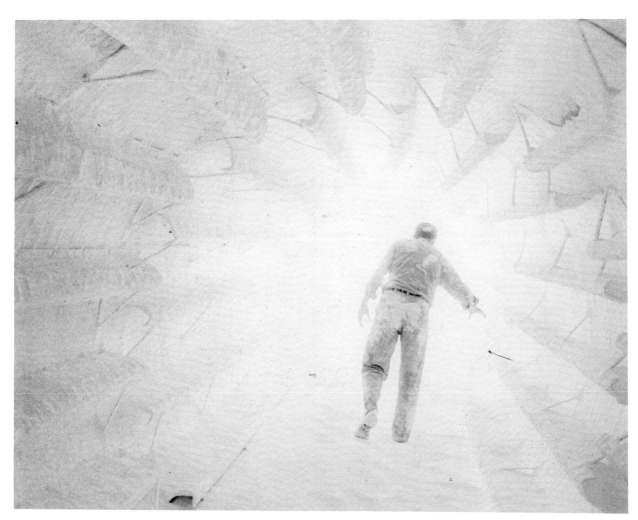

From an Essay, *The Reign of Chemistry*, 1953

COUNTRY DOCTOR, 1948 "... The immensely influential 'Country Doctor' was
a pivotal essay. It was in fact an unresolved mixture of past and future styles.
In its *text* and *layout* it looked backward to the literal reportage of earlier
years—it might have been titled '*Life* Visits a Country Doctor.' But the best of
the photographs ... dealt not simply with what the doctor did, but in the
profoundest sense, with who he was. With this example the photo-essay moved
away from narrative, toward interpretive comment."

—*John Szarkowski, March*, 1965

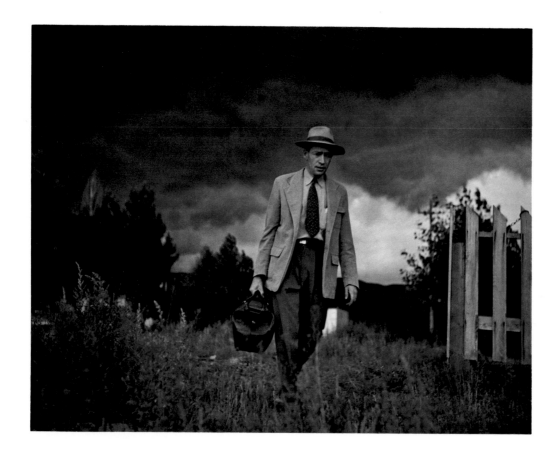

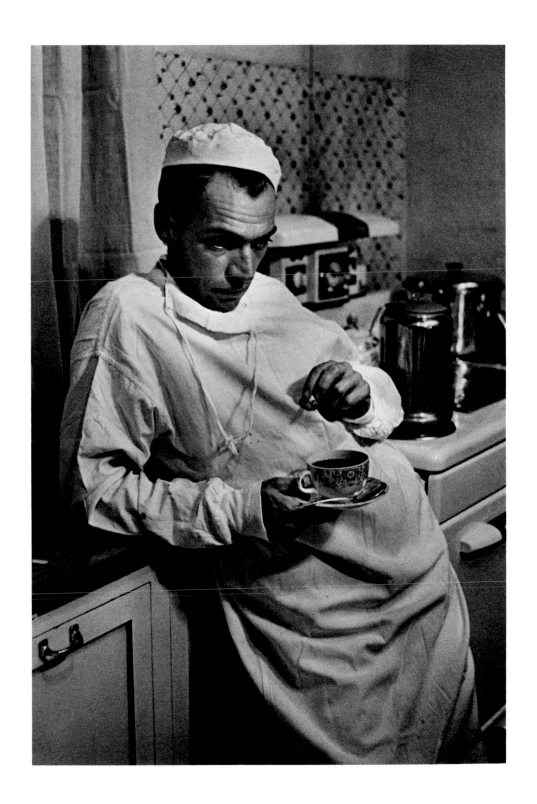

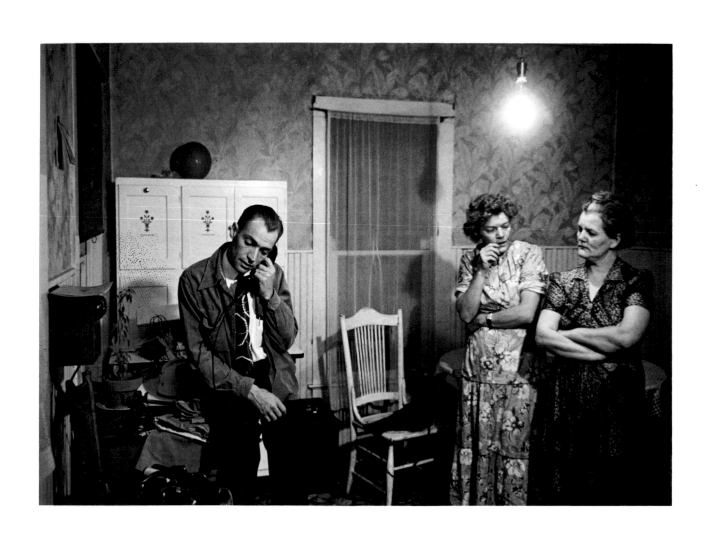

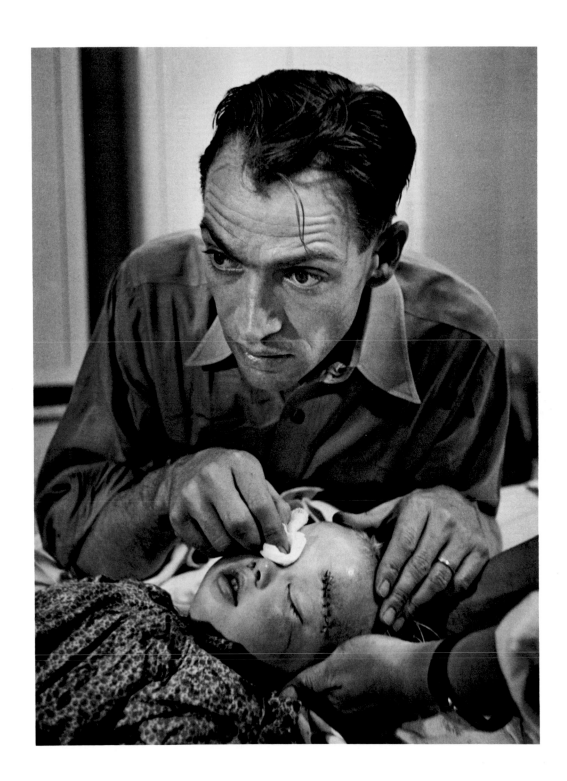

RESEARCH IN GERM-FREE LIFE, NOTRE DAME UNIVERSITY, 1949

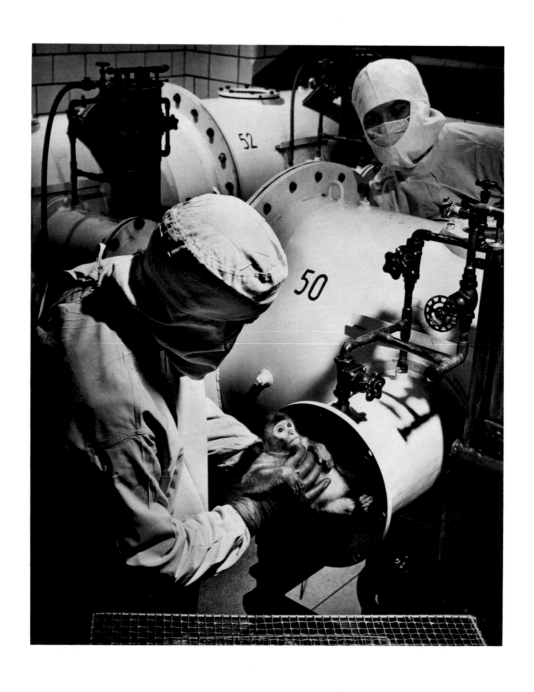

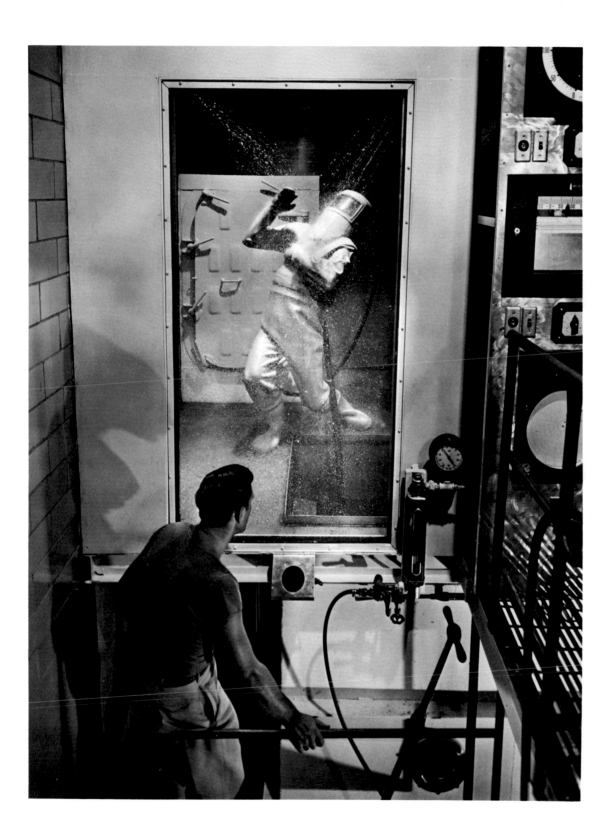

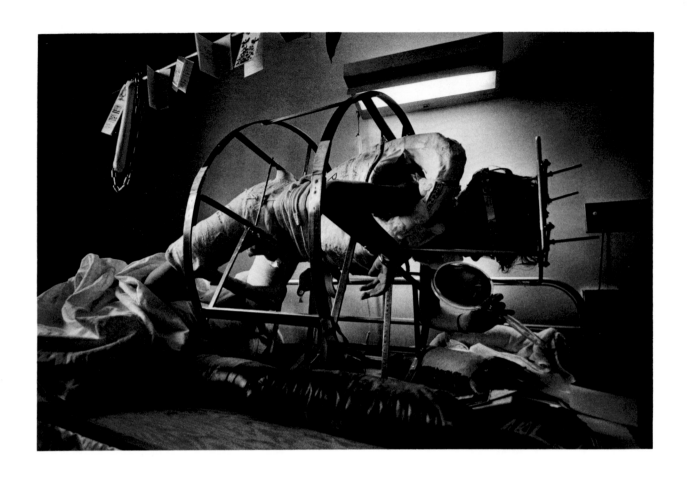

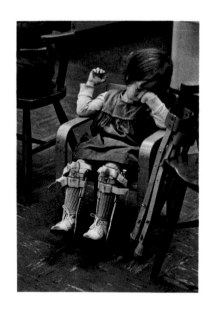

THE HOSPITAL FOR SPECIAL SURGERY, NEW YORK, 1966

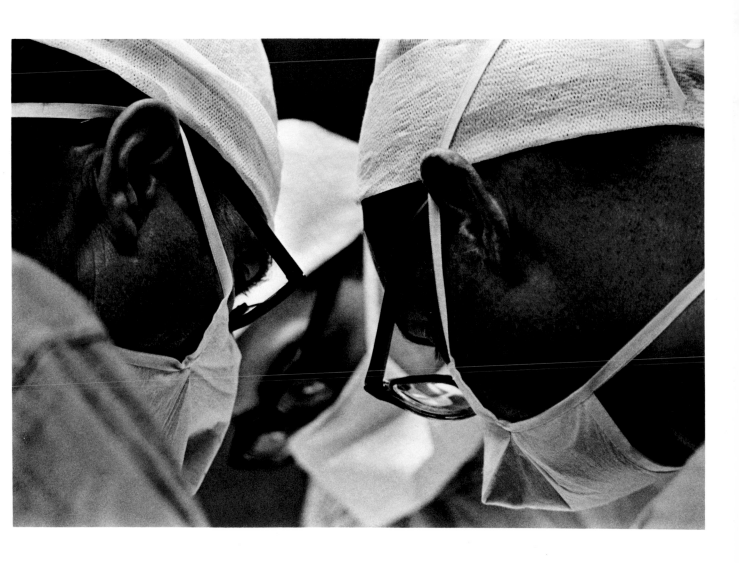

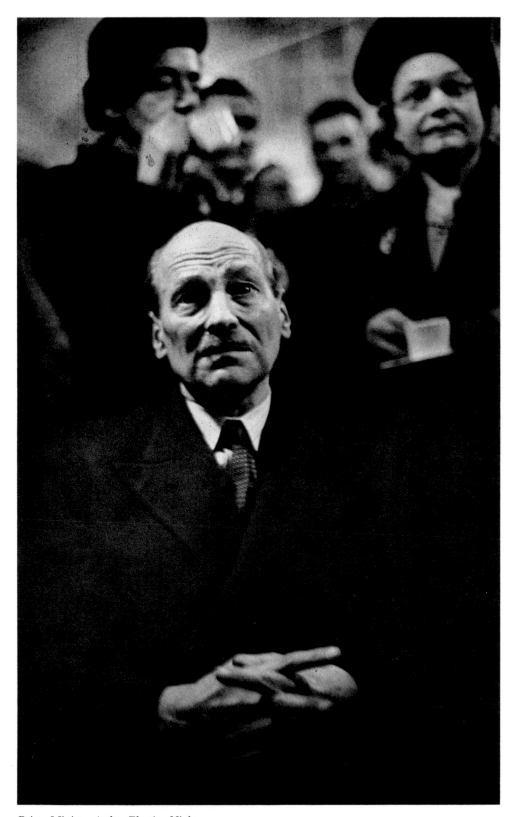

Prime Minister Attlee, Election Night, 1950

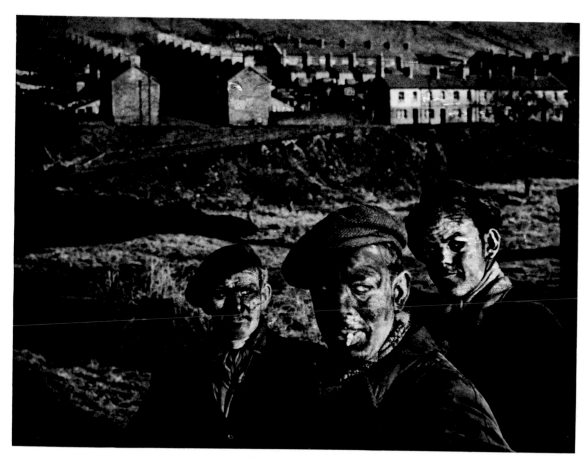

Wales, 1950

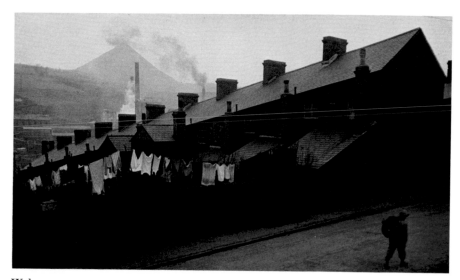

Wales, 1950

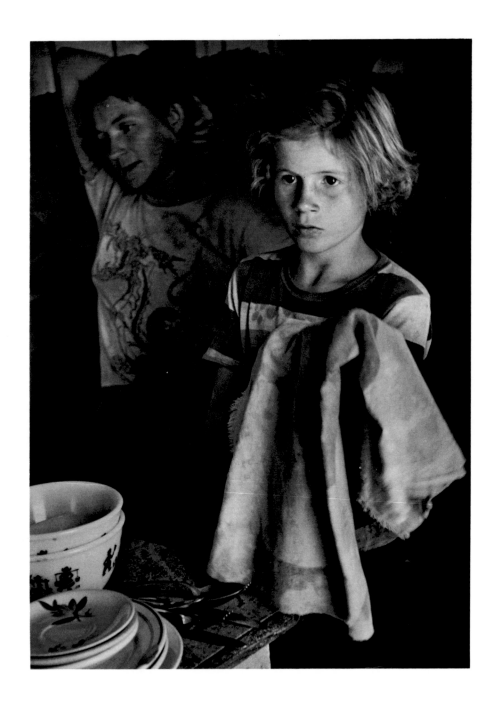

MIGRANT WORKERS, 1953

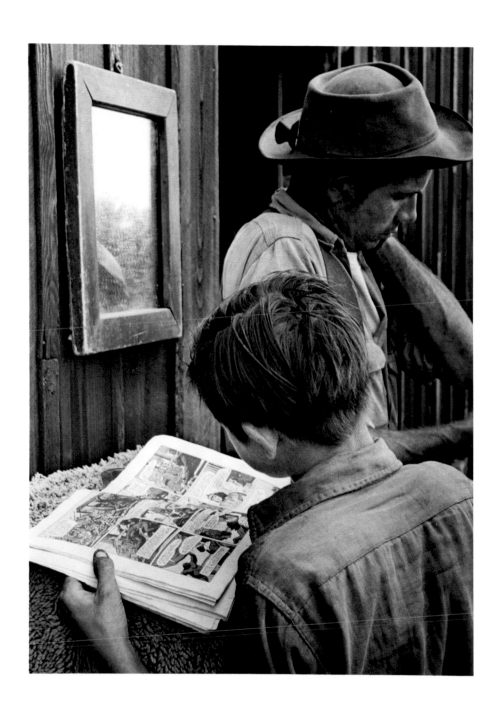

SPANISH VILLAGE, 1951 Away from the publicized historical attractions,
away from the unrepresentative disproportion of the main cities, away from
the tourist landmarks, Spain is to be found. Spain is of its villages, simple
down to the poverty line, its people unlazy in slow-paced striving to earn a frugal
living from the ungenerous soil. Centuries of the blight of neglect, of
exploitation, of the present intense domination weigh heavily; yet the people
are not defeated. They work the day and sleep the night; struggle for and
bake their bread. Believing in life, they reluctantly relinquish their dead.

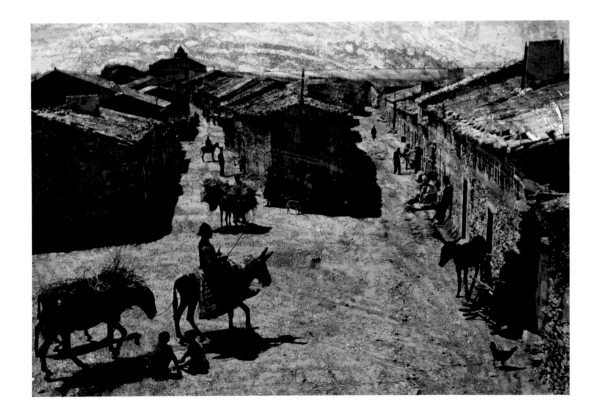

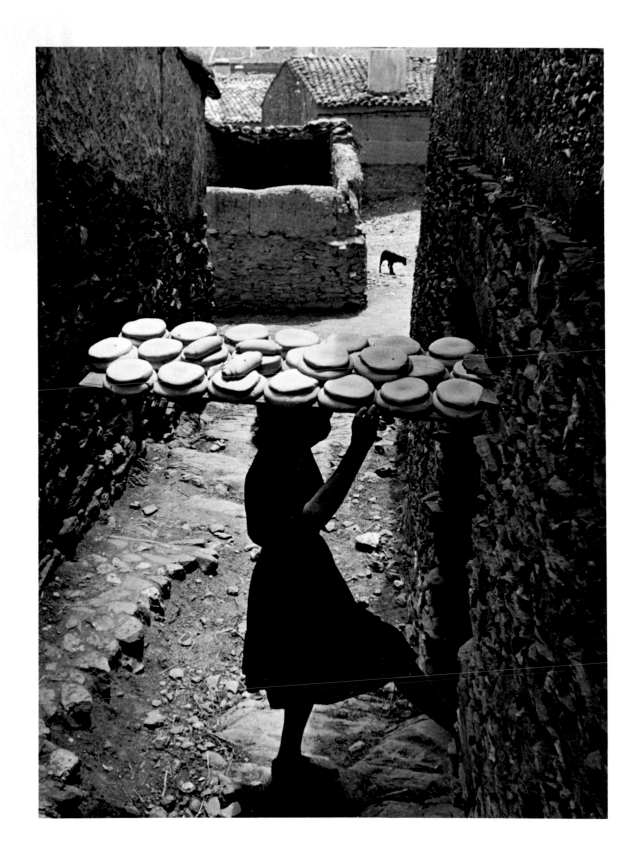

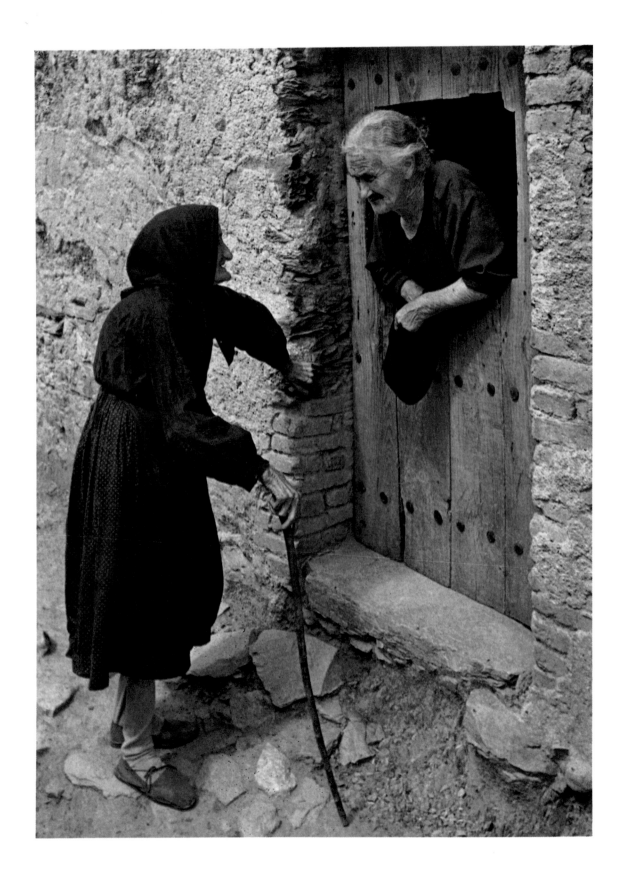

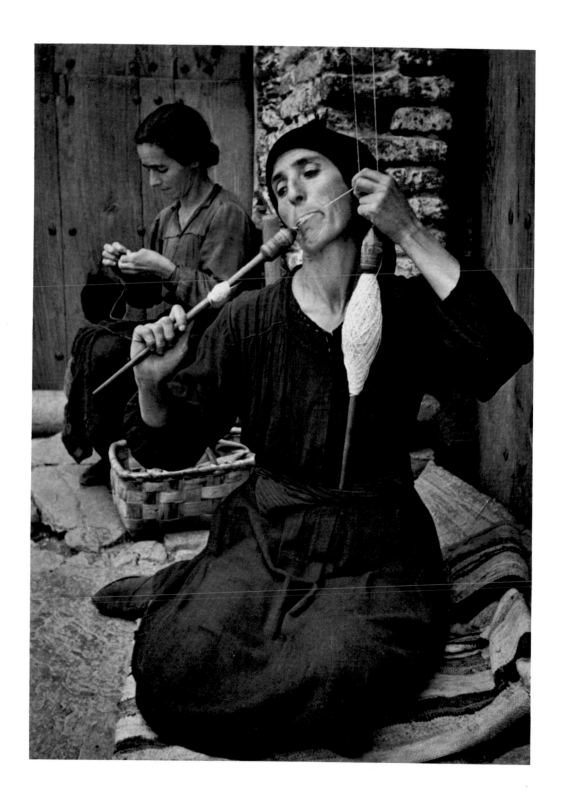

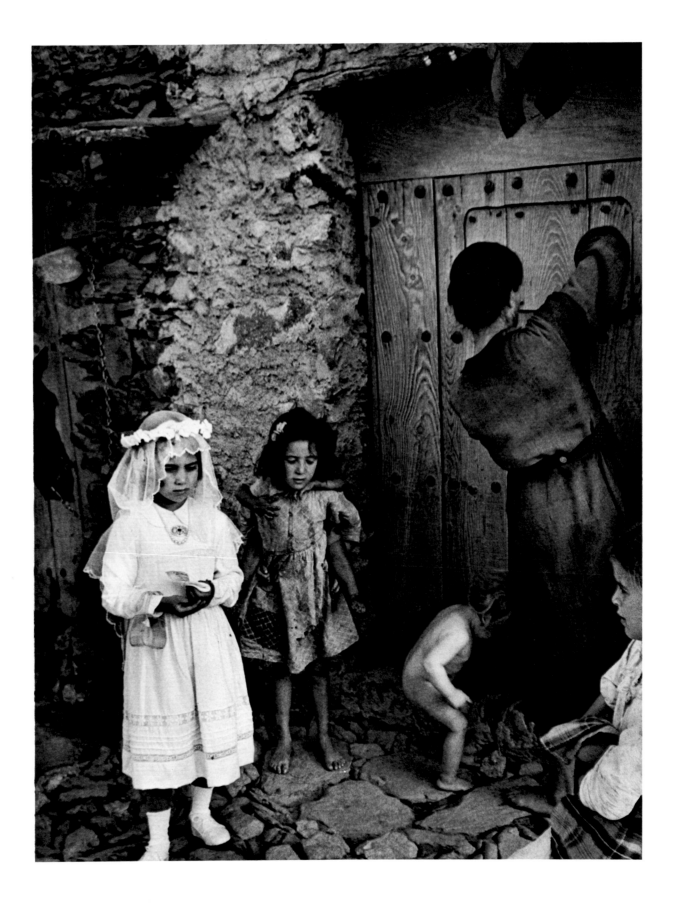

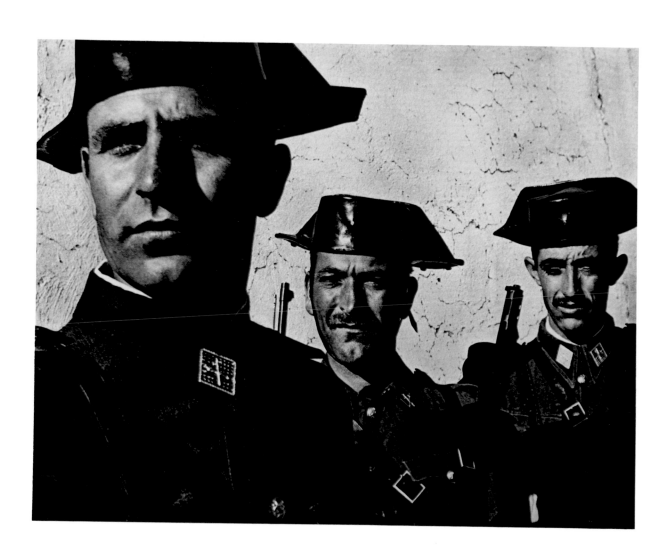

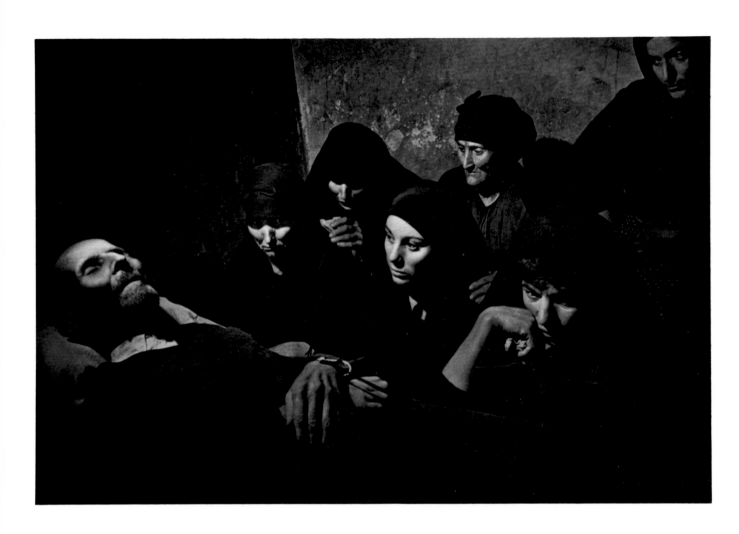

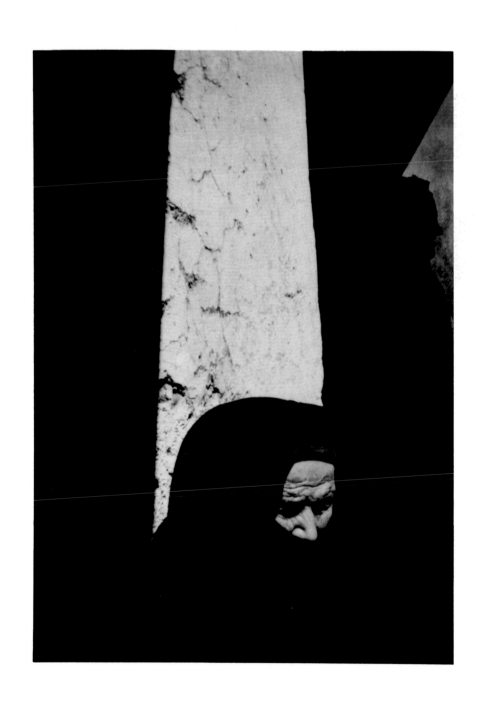

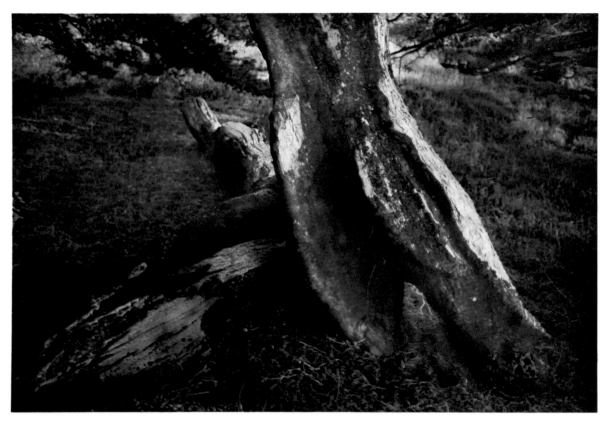

Point Lobos, 1957

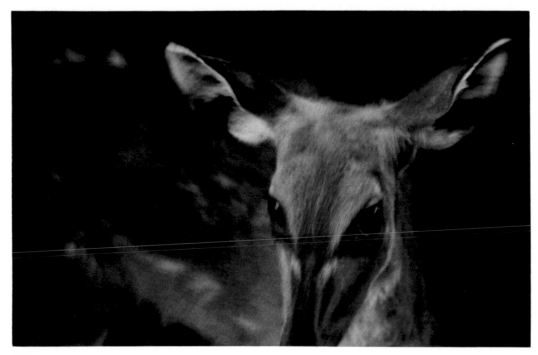

Africa, 1954

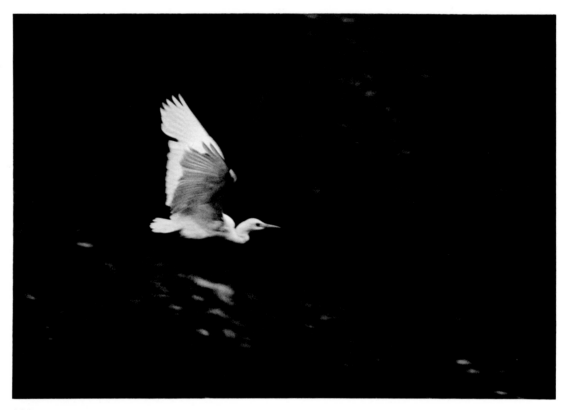

Africa, 1954

Silver Lake, 1958

NURSE MIDWIFE: NORTH CAROLINA, 1951 This essay on the nurse midwife,
Maude Callen, is, in many ways, the most rewarding experience photography
has allowed me. The published story received an overwhelmingly good
response, but more than that, there is the woman herself.

In the most special way, she is probably the greatest person I have been
privileged to know; combining a marvelous wisdom and compassion, a strength
of true humility and true pride, all given direction through knowledge and
purpose in a sheerly beautiful balance. She lives out her dedicated life
against insufferable odds, paying heavily of herself into her accepted
responsibilities without the slightest sense of martyrdom, believing in the
help of God as long as she, Maude Callen, does the work. She is, to me, near
the pure ideal of what a life of affirmative contribution can be. She is perhaps
the most completely fulfilled person I have ever known, even though her
legacy will be little marked in history.

At the time of the essay she bore near-total responsibility for several thousand
scattered, swamp-bound, backwoods individuals, nearly all impoverished.

They are better off for her care, and I am a better person for her influence.

If this sounds like a love letter, it is.

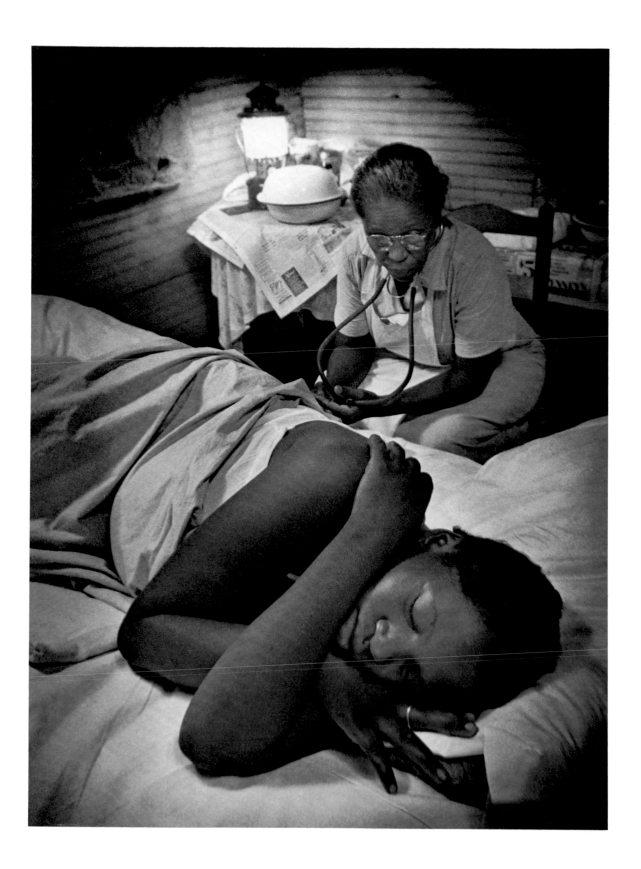

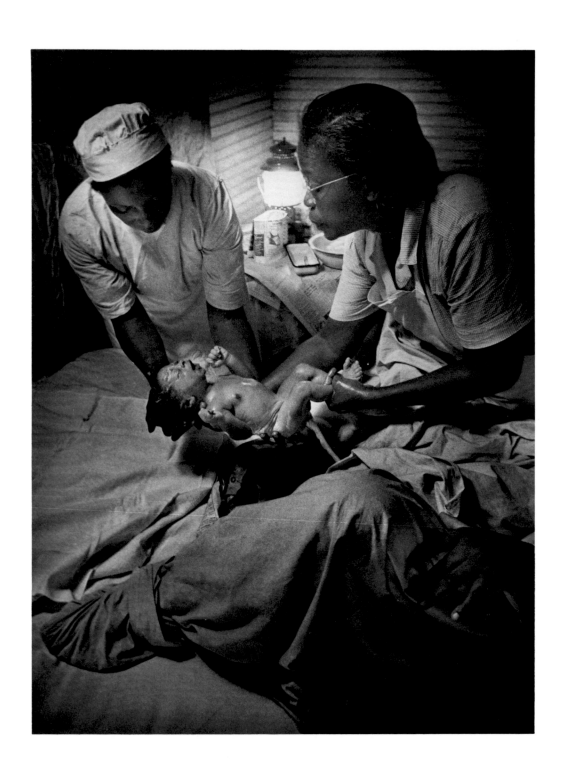

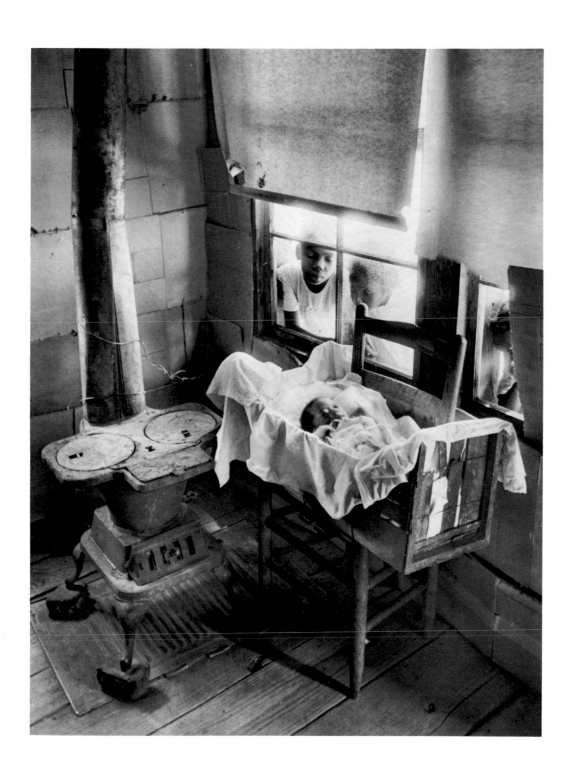

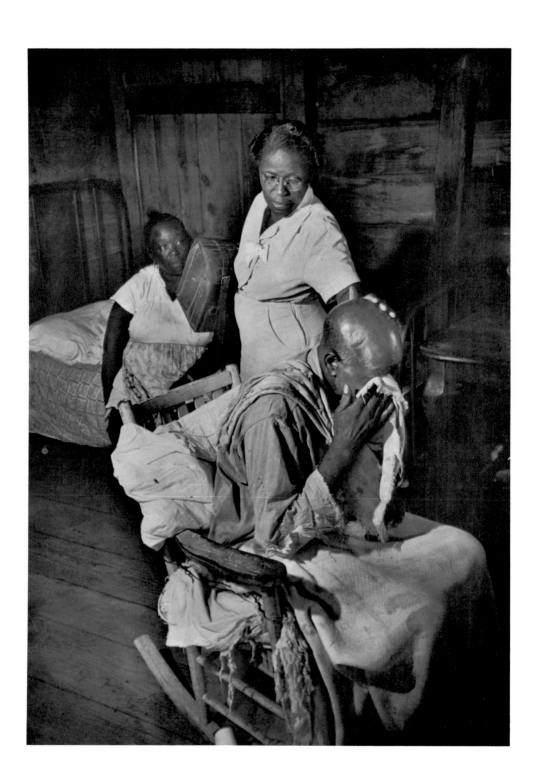

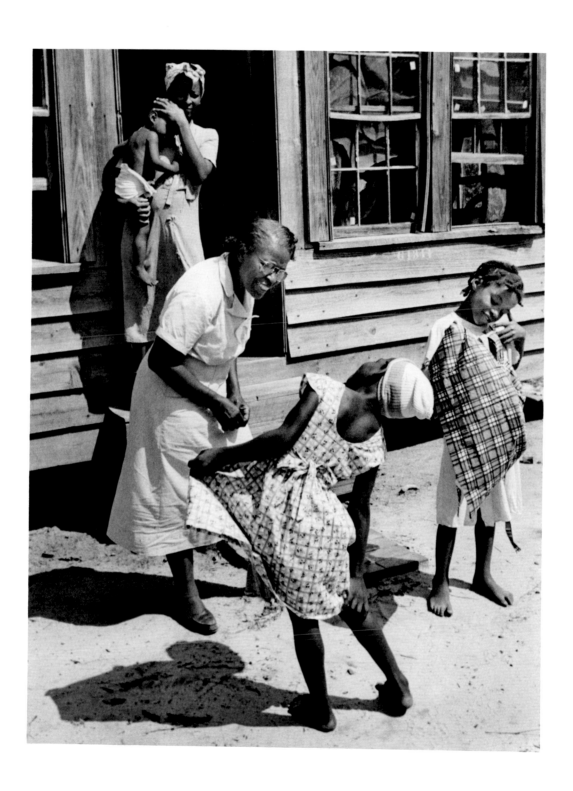

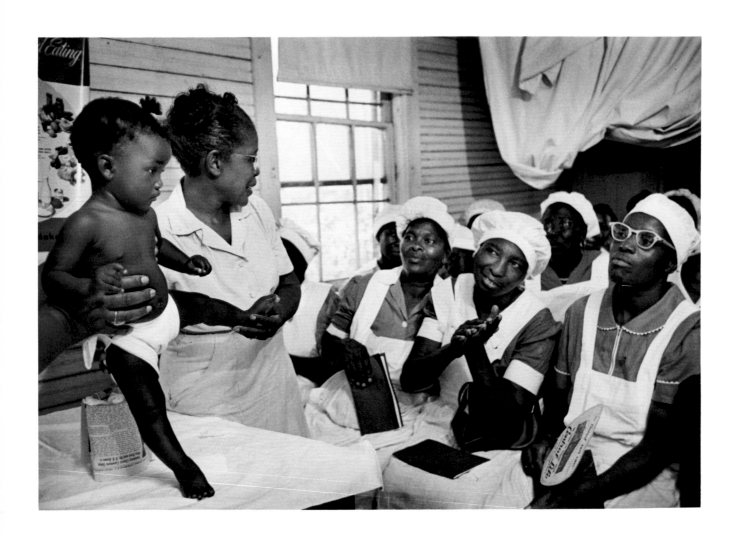

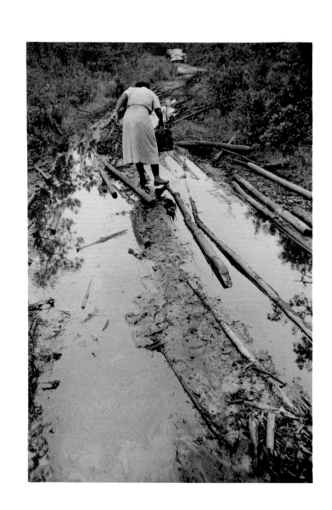

K. K. K.

Dear_____ (an editor);

P. S. In printing the photographs of the white-gowned Klan members
I ran into considerable difficulty. There were several with uncovered faces,
and these faces were so vividly dark in comparison to the white-white of the
gowns that it was almost impossible to keep them from appearing black.

I'm terribly sorry.

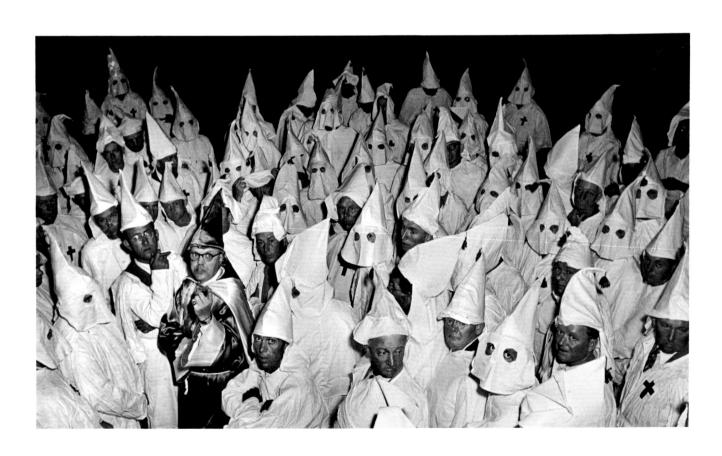

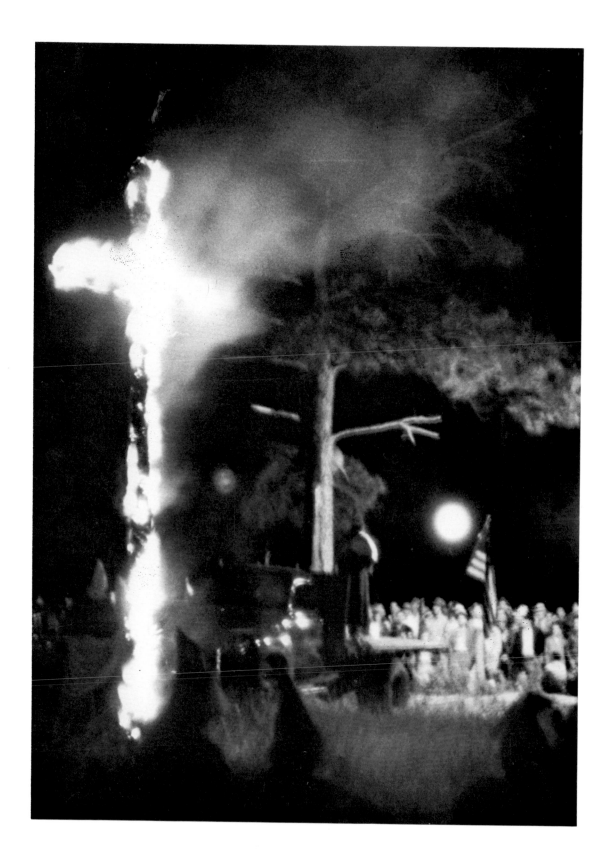

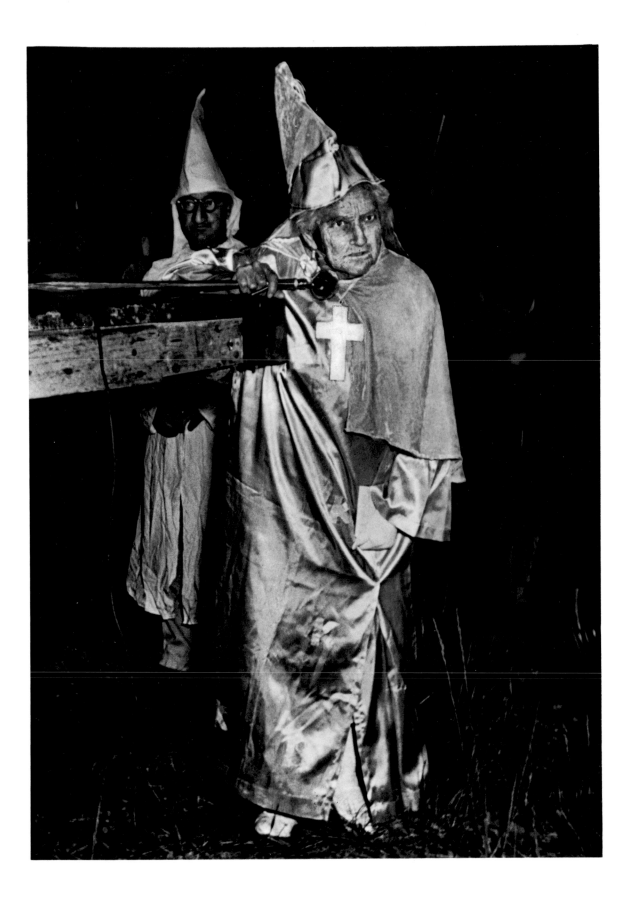

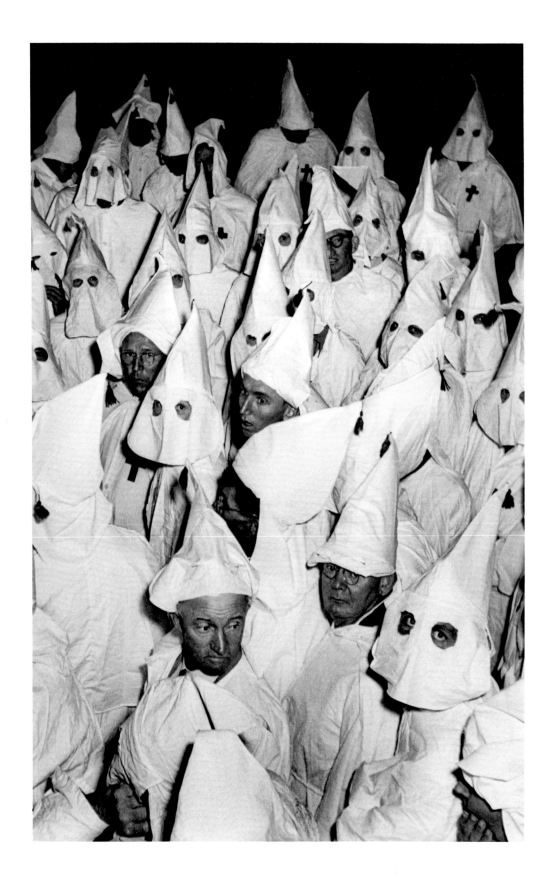

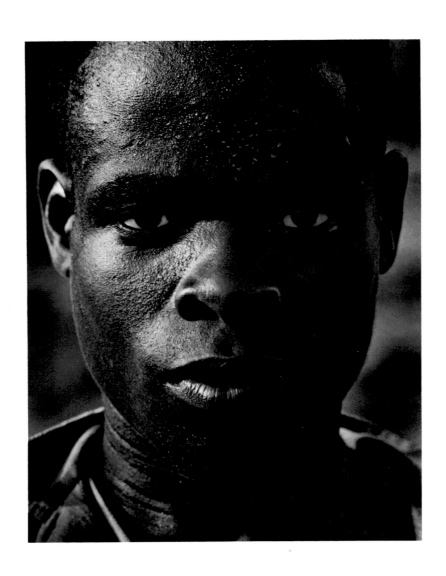

DR. SCHWEITZER, AN AFRICAN PLACE, 1954 Dr. Albert Schweitzer. The man
and his place are hard to confine, or define, within the fabric of their
legend; for actuality is conceived in paradox while legend tends to an
exaggerated simplicity as conceived in the imagination. Remoteness is
important to the sustaining of a legend, although closeness can also distort
reality with excessive detail. At both extremes the narrow mind is susceptible
to varying forms of blindness.

If he arrives unprepared—and most visitors come terribly unprepared
if legend is their only sourcebook—a visitor to the African domain of this doctor
of music, of philosophy, theology, and of medicine will be terribly bewildered
and ofttimes shocked if his vision is Western in illusion—conditioned and
narrow and unyielding.

The visitor, unprepared, will even have difficulty in trying to determine
the nature of the place: whether it is an African village, a game preserve, or
a medical hospital. Actually, it is the sum of all three. It is of a wisdom, a
philosophy, a total meaning uniquely its own. It is of one man laboring to
accomplish according to his beliefs, with disregard for conformity and with a
tremendous regard for the realities at point-blank range.

A giant of a man cursed with mortality and with a legend that bestrides
him. I agree with his admonishment: "And none of the 'greatest man in the
world' nonsense." On this level I have a deep admiration and sympathy
for him—even as he towers over most men.

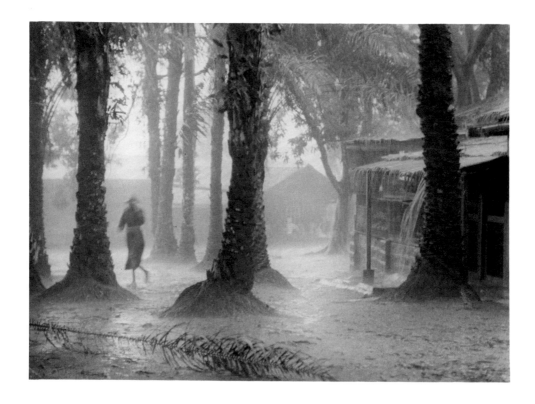

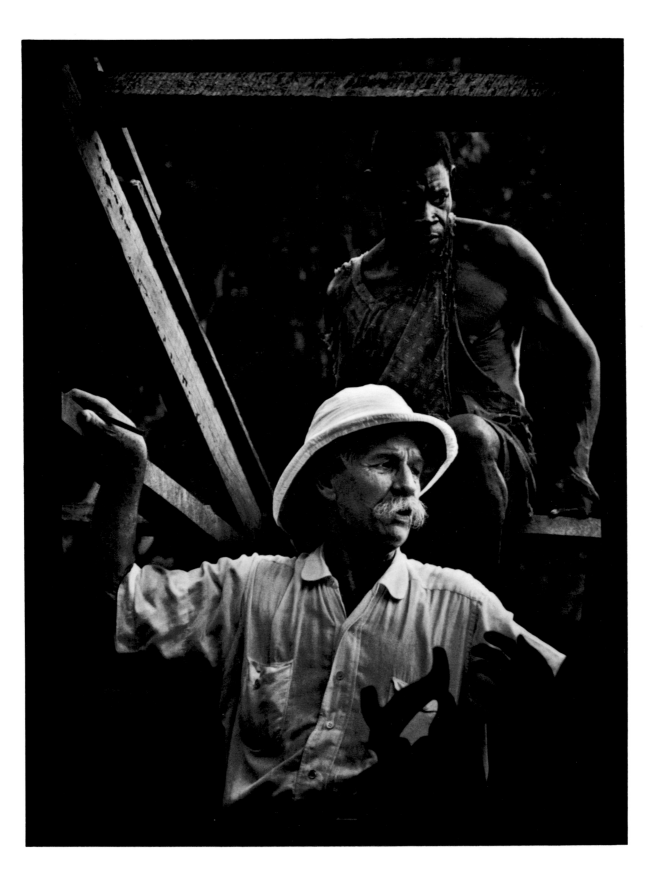

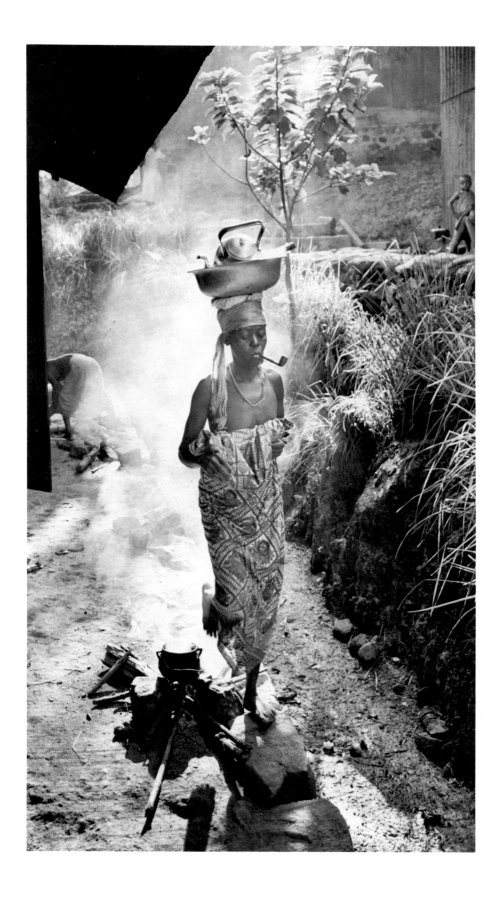

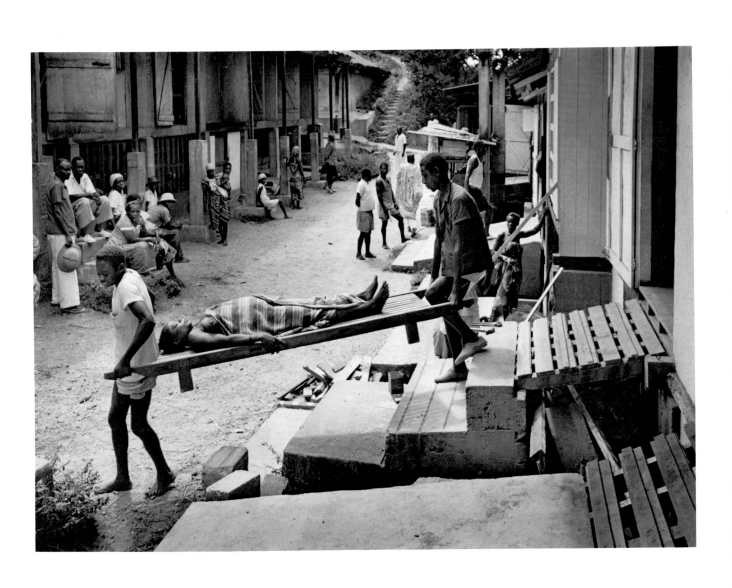

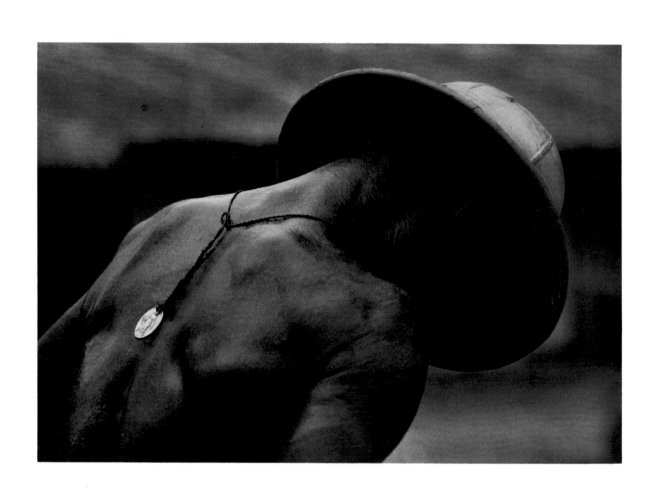

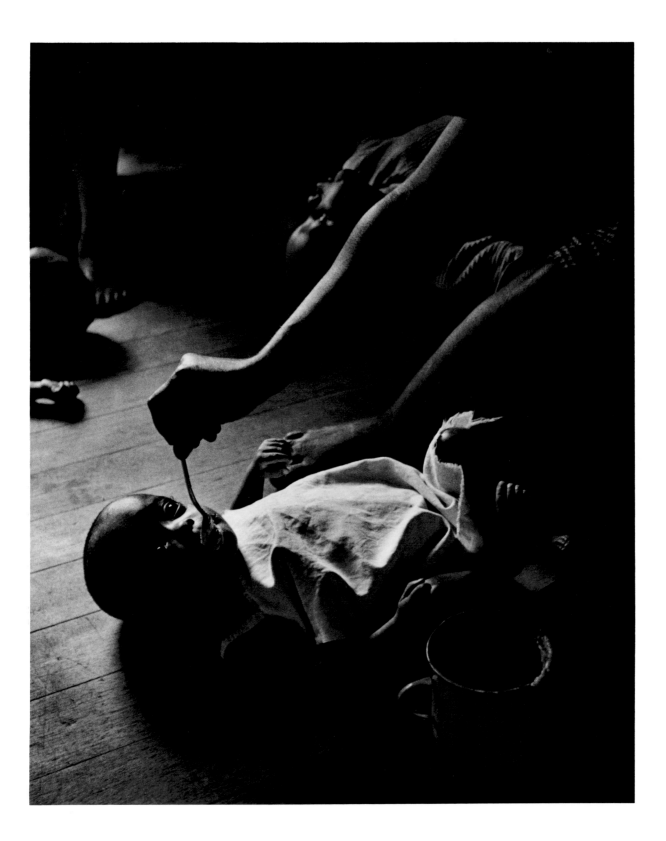

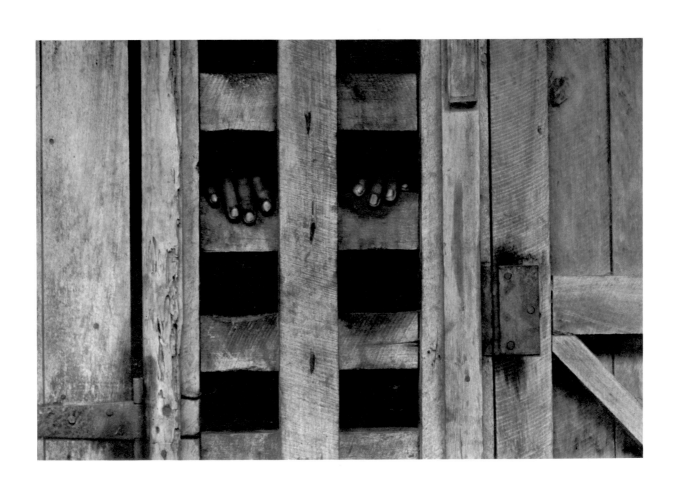

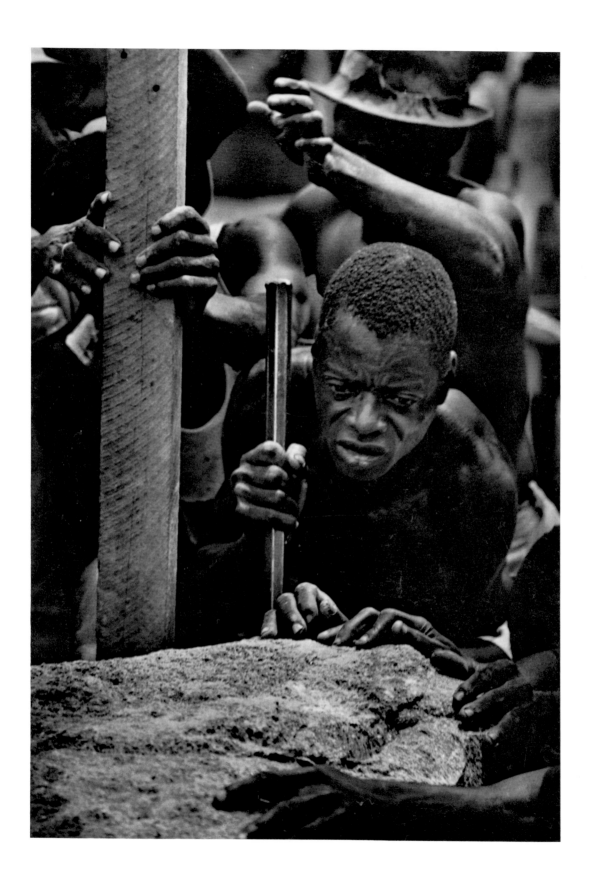

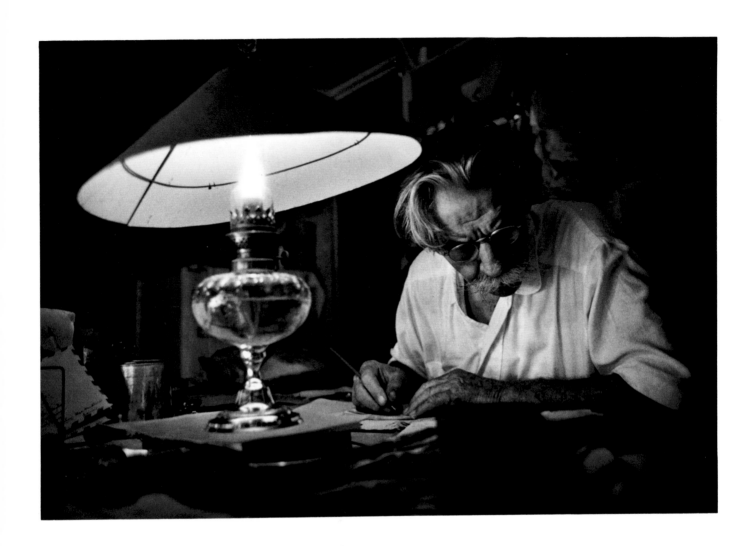

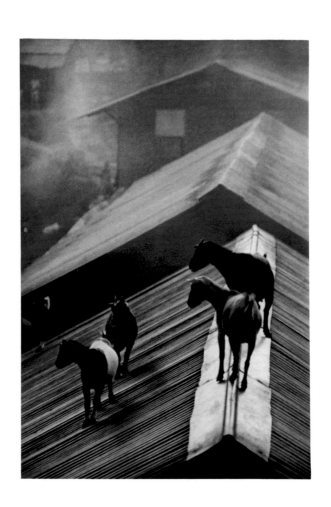

PITTSBURGH, A LABYRINTHIAN WALK, 1955 To portray a city is beyond
ending; to begin such an effort is in itself a grave conceit. For though the
portrayal may achieve its own measure of truth, it still will be no more than
a rumor of the city—no more meaningful, and no more permanent.

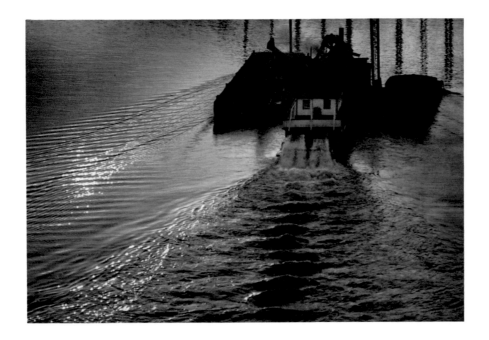

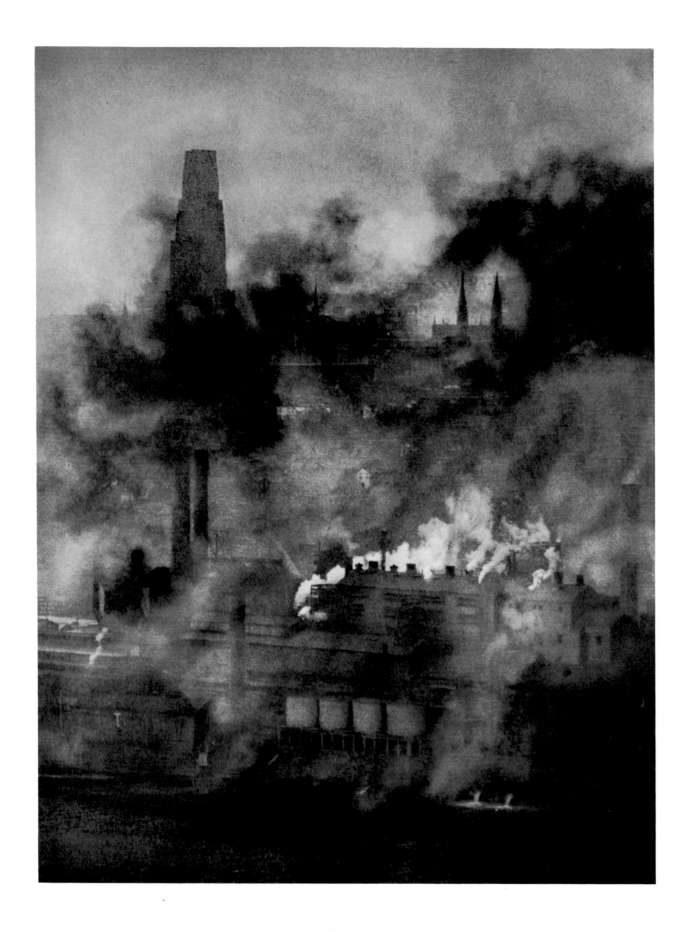

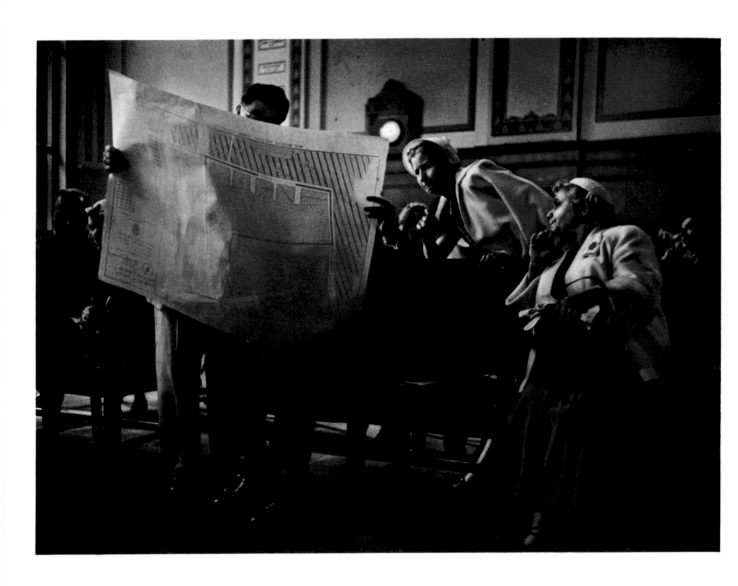

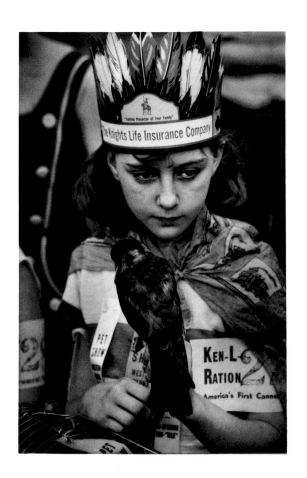

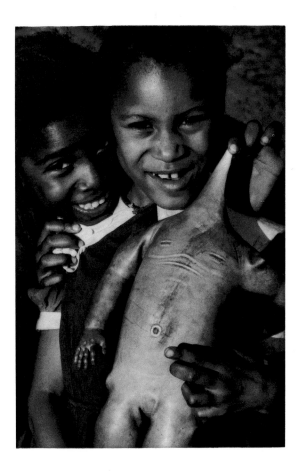

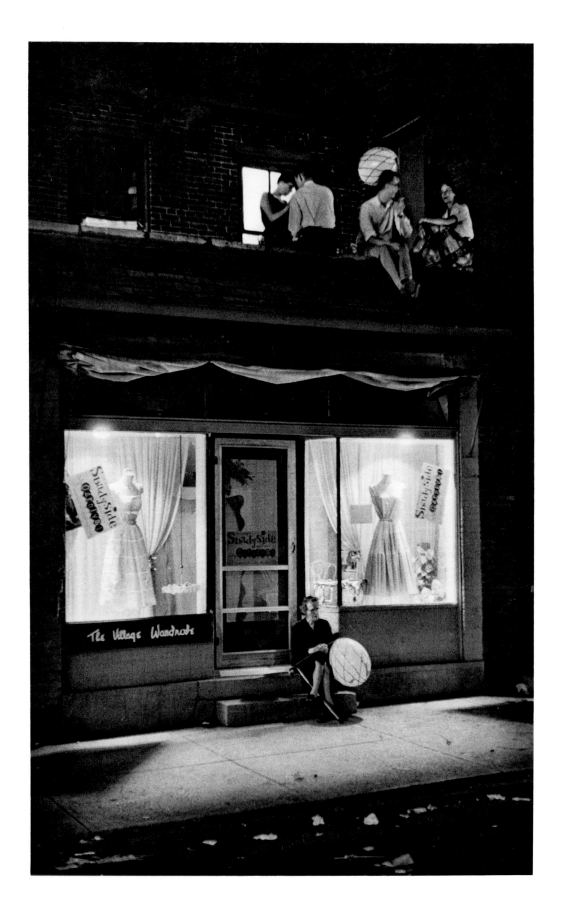

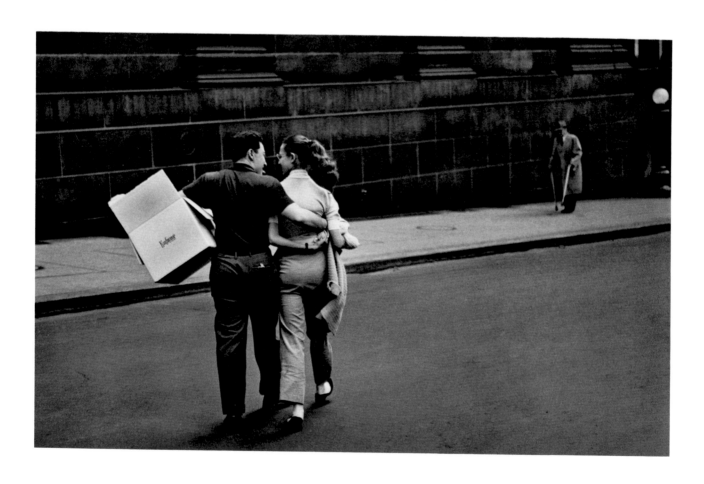

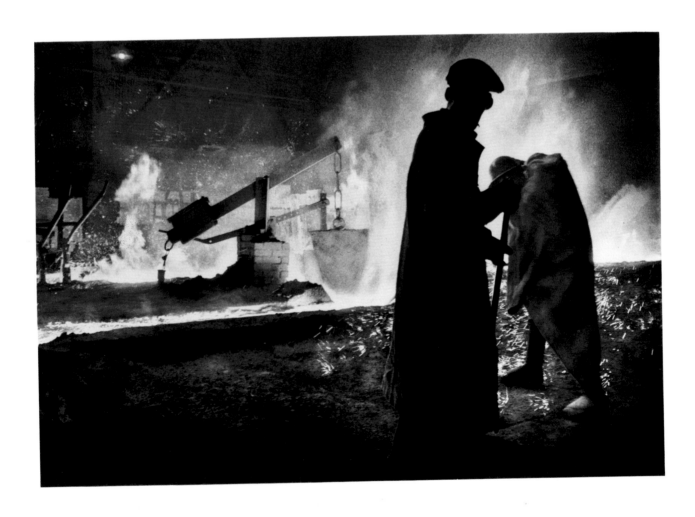

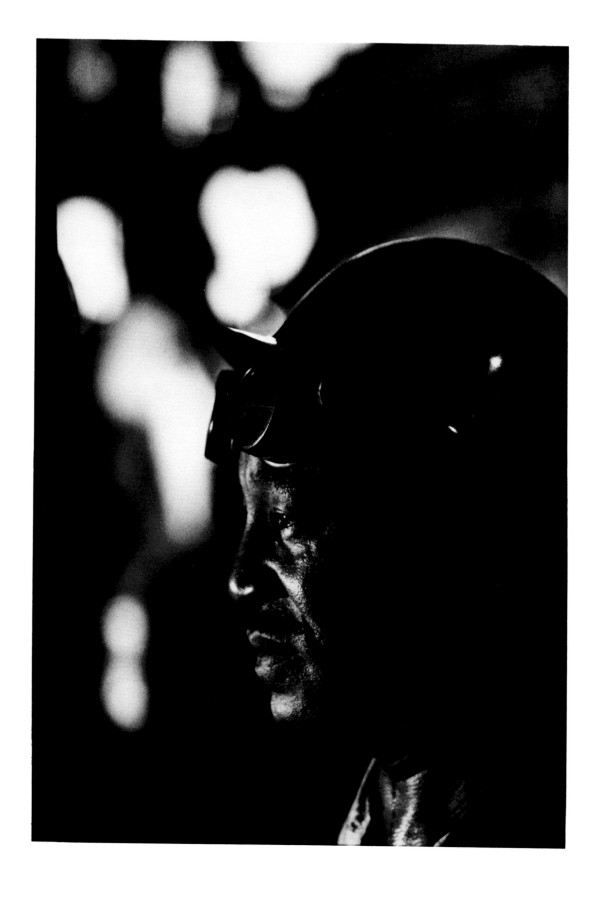

HAITI, A BARREN, STARVING, BEAUTIFUL LAND, 1958-59 Individual pictures
brought together that begin to make a kind of sense . . . not excerpts from
an essay, but the embryo of one.

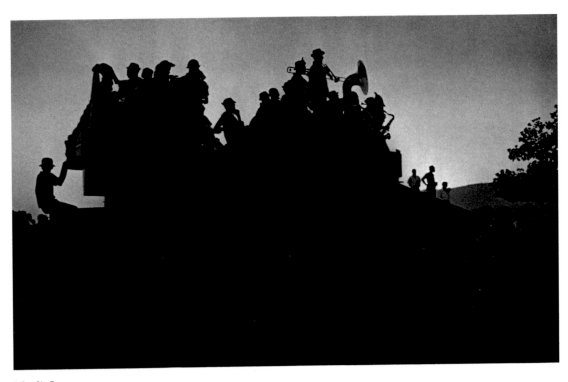

Mardi Gras, 1959

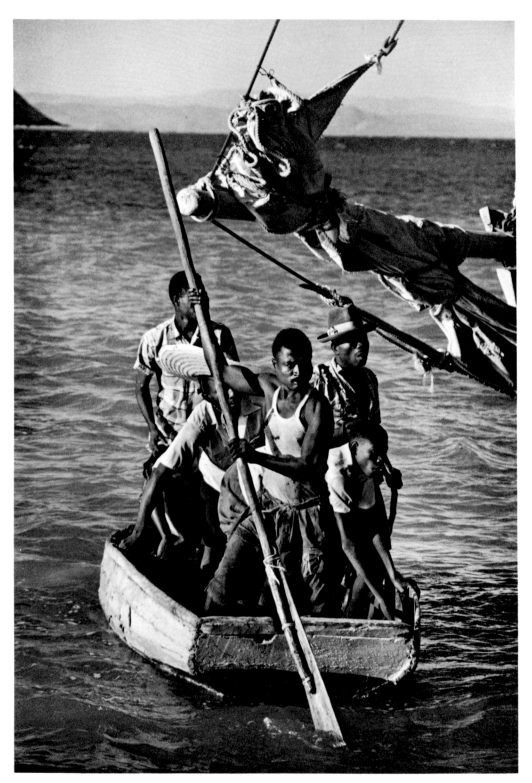

Isle of Tortuga, 1958

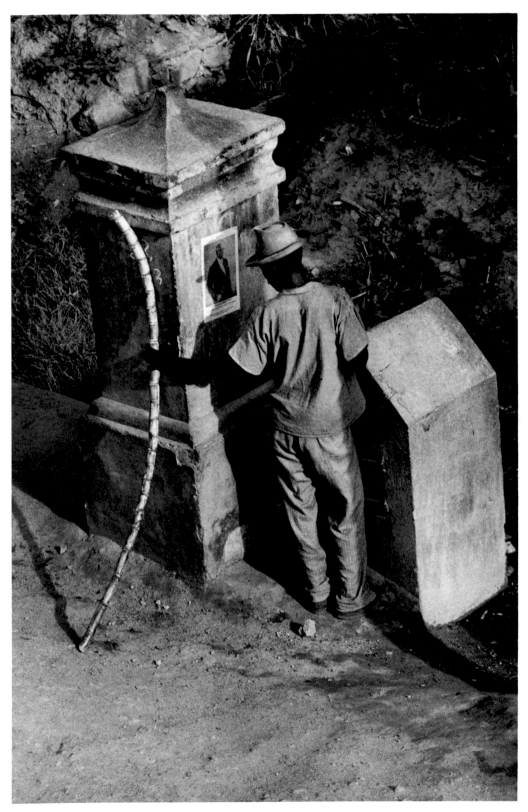

1958

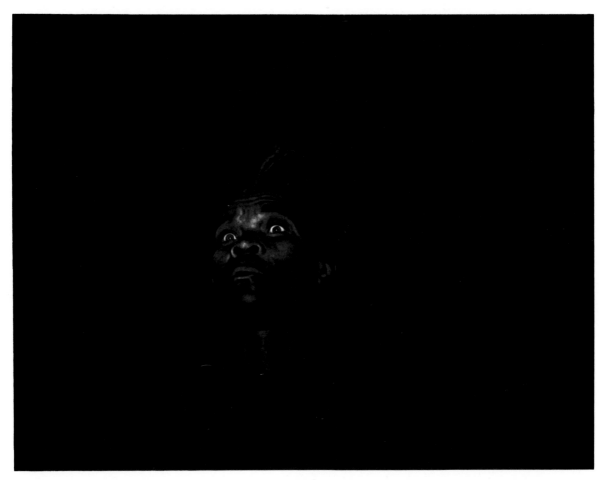

Madness, 1959

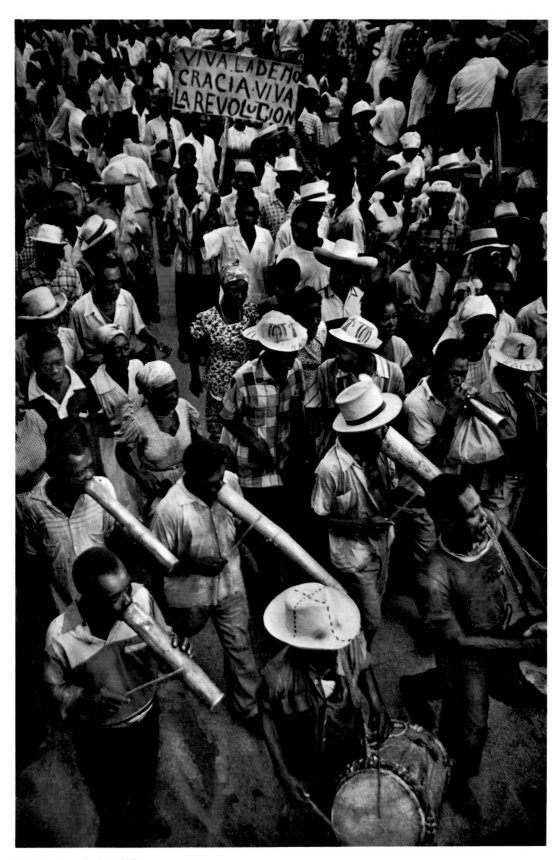

Not Far from the Mardi Gras, 1959

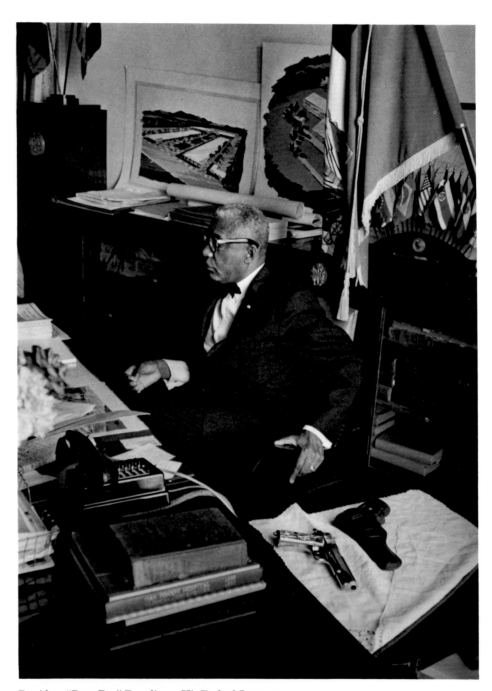

President "Papa Doc" Duvalier at His Desk of Government,
with Tools, Including a Bible and a Prescription Pad, 1958

As From My Window I Sometimes Glance The loft I live in, from inside out. A dirty, begrimed, firetrap sort of a place, with space. It has claimed— together with another view, one of "inside in"—more film than I have ever given to any project. The reasons: on the outside is Sixth Avenue, the flower district, with my window as proscenium arch. The street is staged with all the humors of man, and of weather, too.

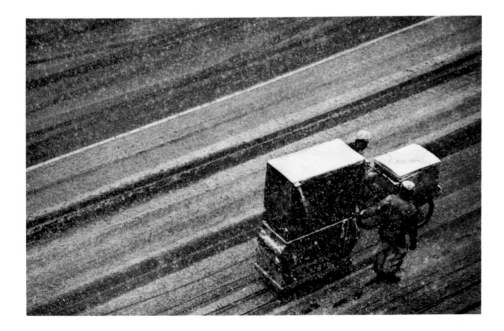

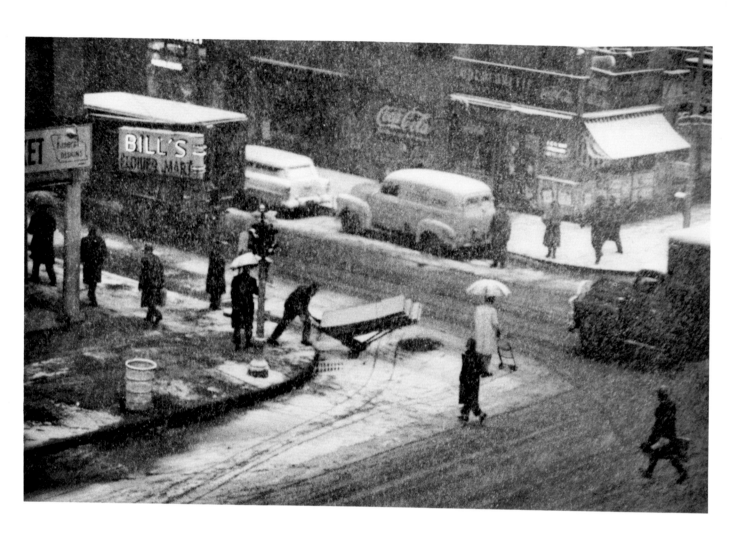

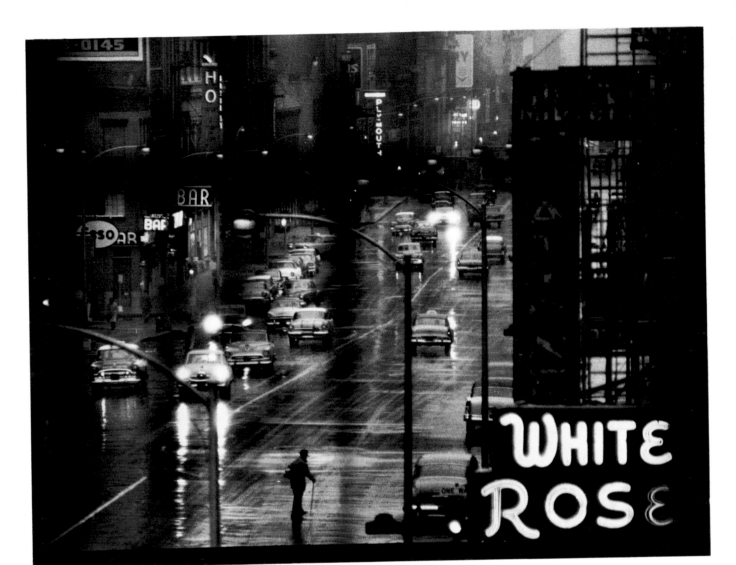

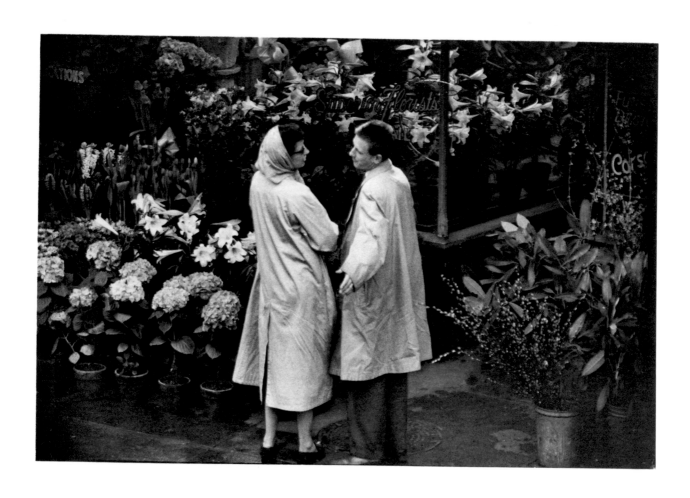

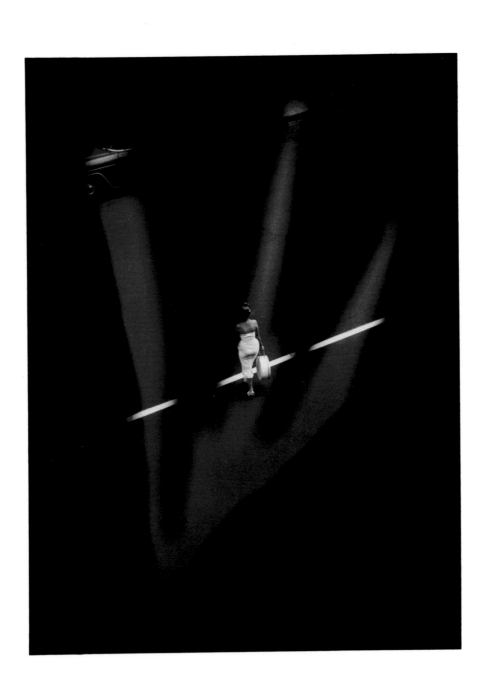

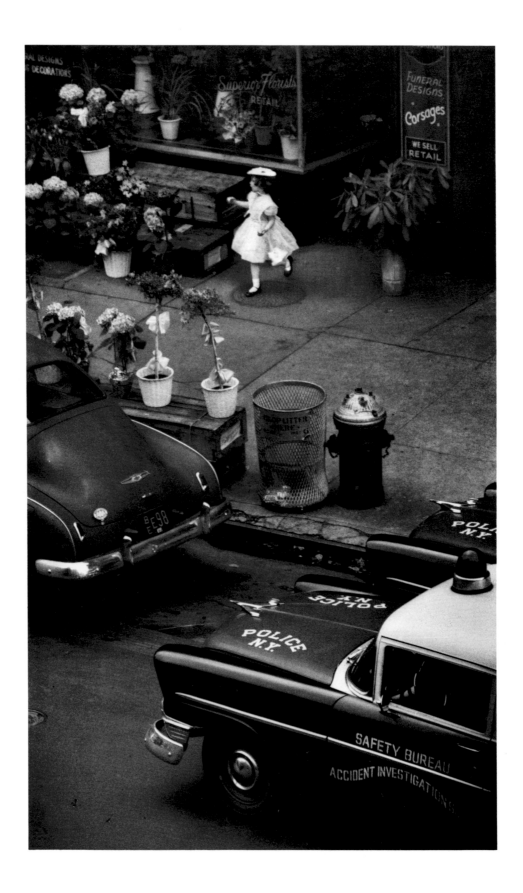

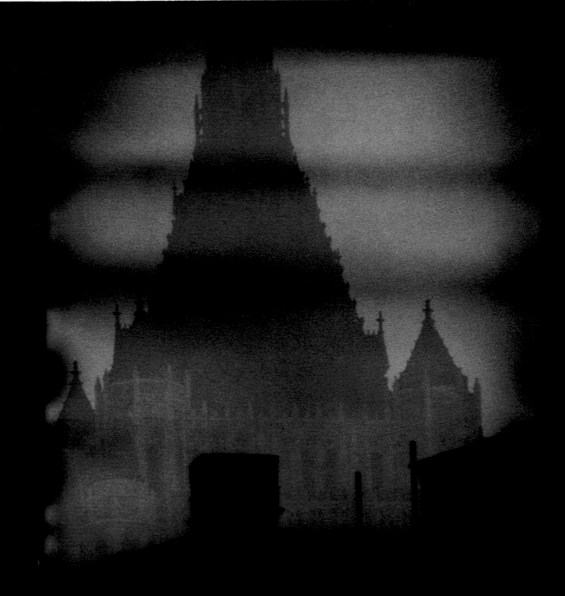

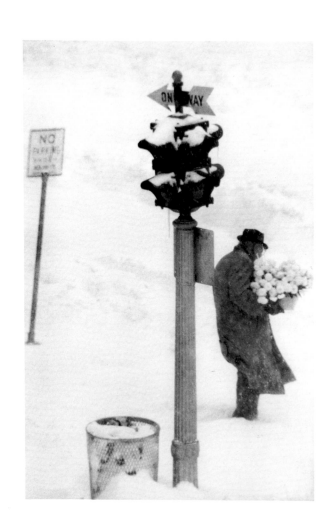

THE LOFT FROM INSIDE IN Grudgingly admitted: it is a slum-styled loft
building. But for years—less so now—it was an exciting building. A place to
work, noise at any hour, and each individual who used the place—each had
something to offer his neighbors. Fine musicians, artists, both embryo and
accomplished. "Chaos Manor," "Confusion Place." The activity of creation
was goaded by the excitement that paraded the place. Happenings such as
three jam sessions going at once caused projection into the avant-garde
through criss-cross blending.

 Now much of the excitement, the mental stimulation, is gone. It is all
but shorn of its vital human chemistry. Ghosts seem to picket the place.
It is now no more than the depressing slum it long has been. A place to leave.

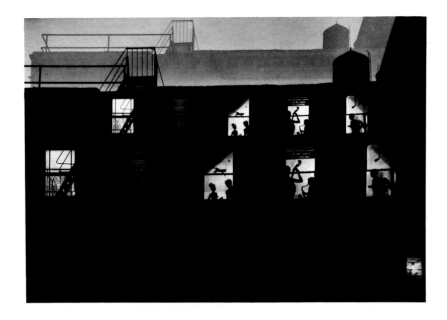

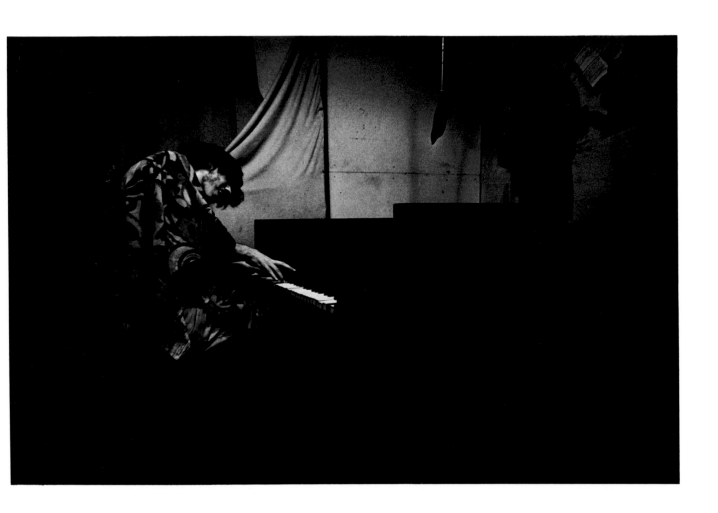

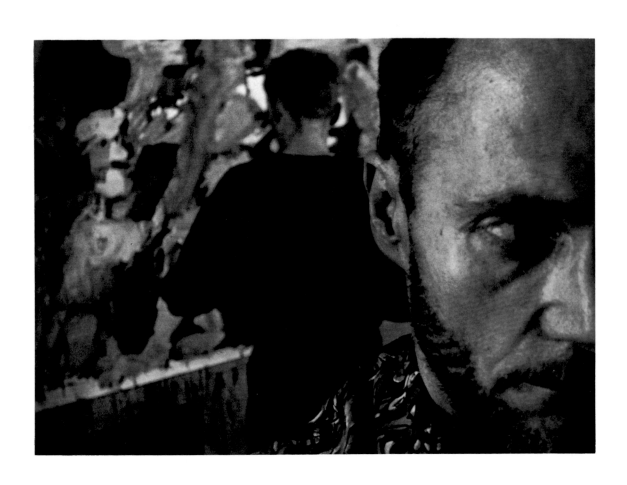

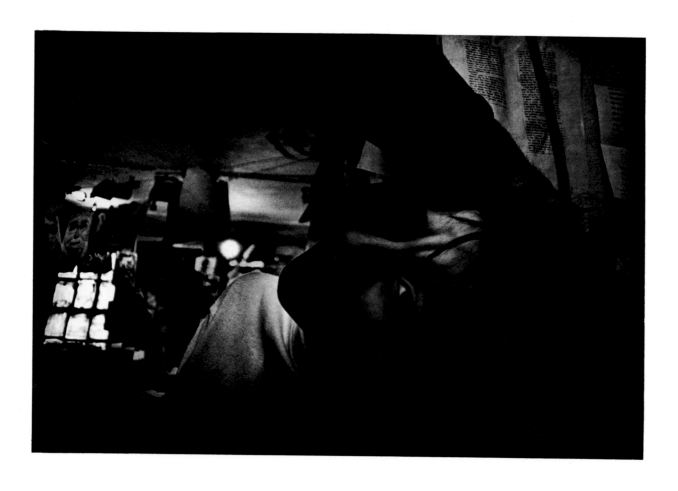

JAPAN: A CHAPTER OF IMAGE, 1962 From an exploratory and experimental, photographic-essay. To maintain integrity, and for perspective, I disclaim any pretense of being an expert on Japan. It must be understood that my thoughts, questions, images, and, certainly, conclusions are from an intense but limited personal experience of some things that are Japanese. And from considerable historical cramming.

 At most, there is a chapter here, by a tourist . . . by a tourist who often finds he is homesick for that remarkable country and its people.

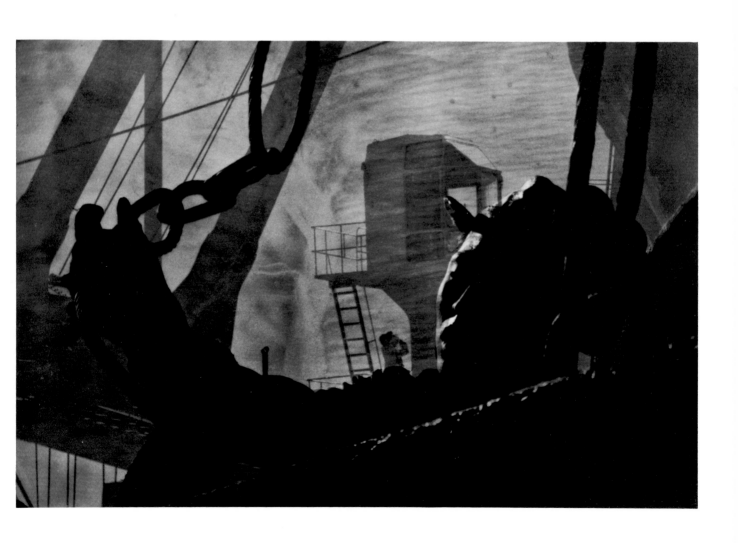

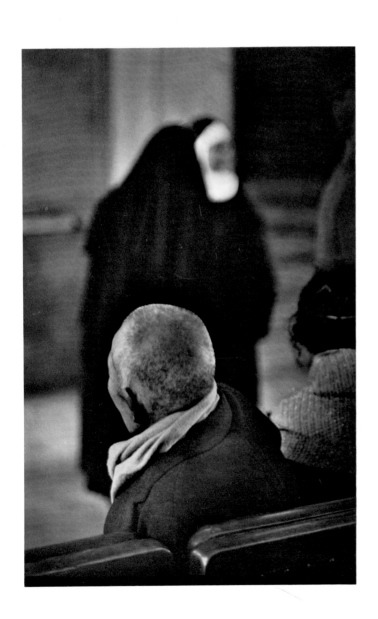

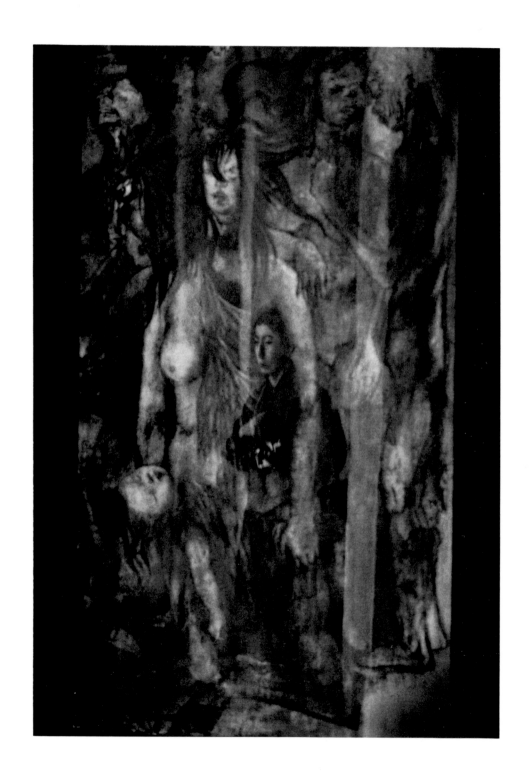

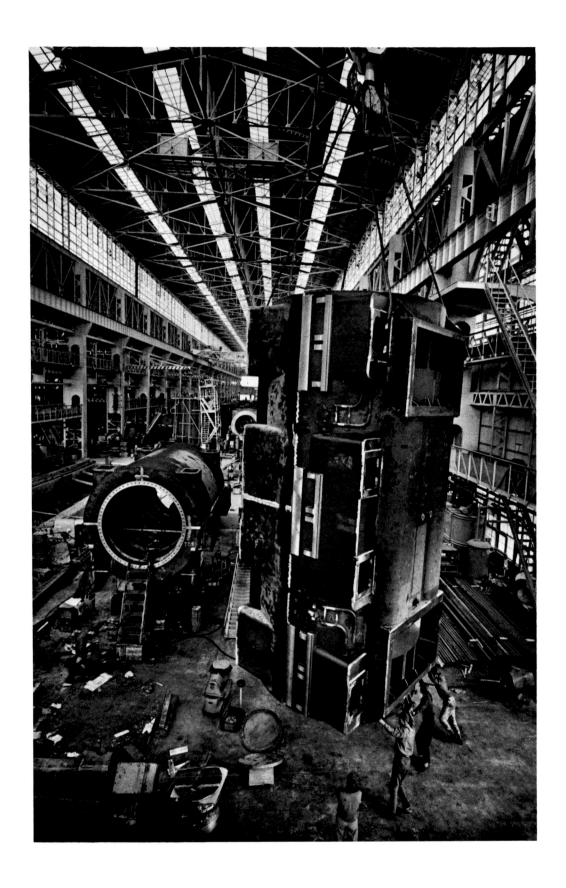

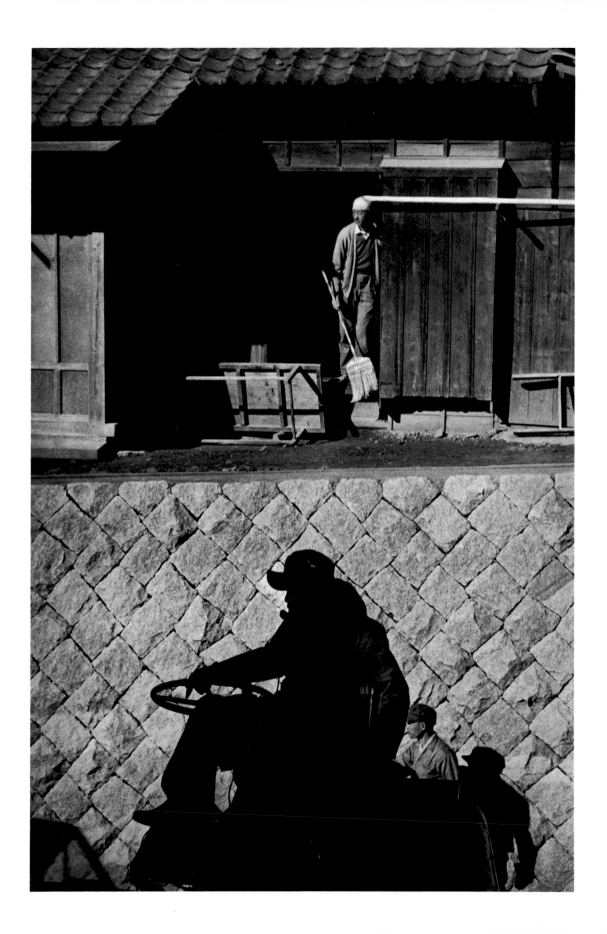

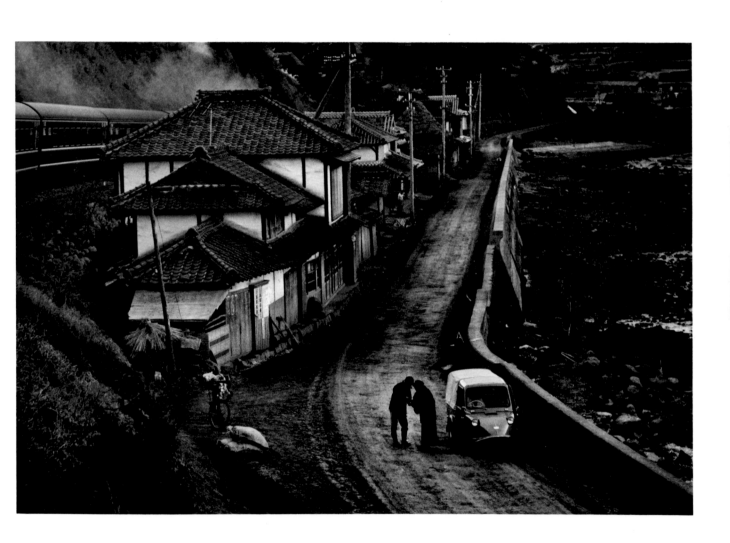

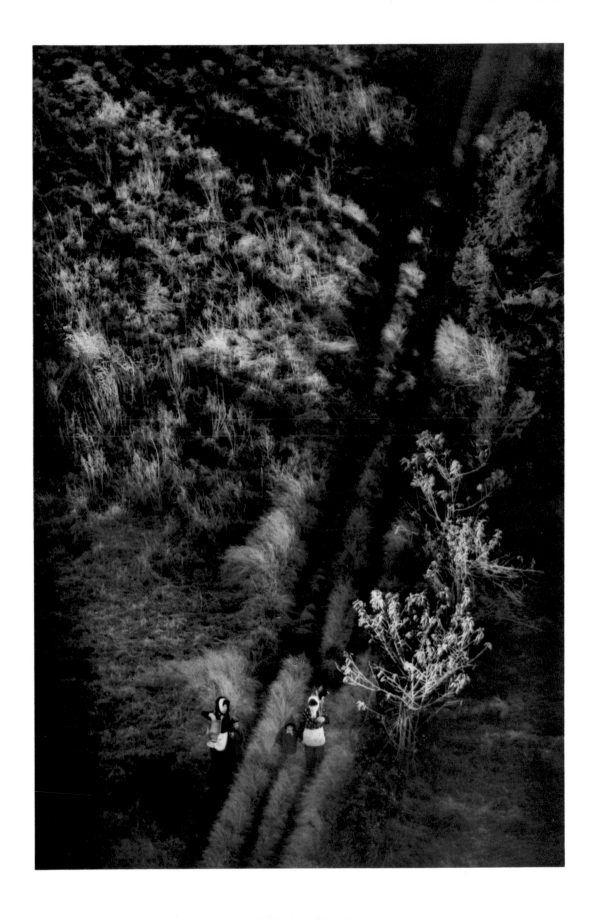

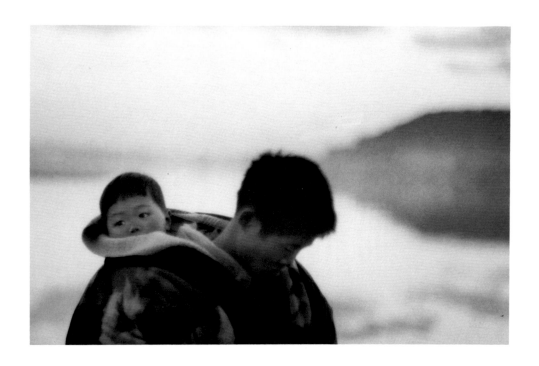

. . . and never have I found the limits of the photographic potential.
Every horizon, upon being reached, reveals another beckoning in the distance.
Always, I am on the threshold . . .

W. Eugene Smith
Success or Failure: Art or History

I. Biographical

Gene Smith first used his camera at age fourteen for aerial photography.
Within a year he turned himself into a pursuer of current events,
a reporter for the Wichita *Eagle* and *Beacon*. These were provincial
heartland papers informing those heirs of the pioneers, who, invading
that 'dark and bloody ground,' had penetrated to our Middle West a
century before. They, like old John Brown in his Mosaic mania toward
abstract justice, absorbed with due violence a Puritan ecology from
the Plains: flatness—no mountains, rigid decency, poverty, possibility,
adventure. In the Twenties, there were no longer buffaloes, Indians,
Brown's nor Cantrill's raiders, but sport still—plus aviation. In 1927,
Charles Lindbergh, a middle-class, Middle-Western youth with
something of a radical political heritage, gave the world an apologue
for unlimited possibility in our conquest of space and time. But this was
also the Dust Bowl era, when pioneer heirs learned to starve in silence
or push on, past where their forefathers had first settled, to an even
more forbidding Pacific coast. An ungenerous land once promising milk
and honey framed images of the plagues of Egypt: starving families
in rusty jalopies, cattle dead in the dust, migratory workers. This was
visible testimony to the rewards of a century of Anglo-Saxon white
Protestant psalm-singing. Smith as a young photo-journalist burned
all his early prints and negatives; they were inadequate in focusing on
the bitter epoch in which he was raised. Modesty, or awe, was born;
a burden of indignation outweighed the innocent placement of effective
or facile images useful to journalism. Later he wrote: "I had an
intuitive sense of timing, an impossibly poor technique, an excitement
to the fact of the event rather than of interpretive insight. Although
I was deeply moved I did not have the power to communicate it."
Smith, about fifteen, already ached with the discrepancy between
"art" and "life." In paint one might struggle with a recalcitrant
medium, overcoming initial clumsiness by digital mastery although
the mechanics had little enough to do with vision or endowment.
In photography you had to make the shutter's click capture a legible
(and symbolically strong) image as fact. Continua of facts make
history but are neither significantly graphic nor beautiful in surface

or pigment. His failure to satisfy as an artist was now salvation as a photographer, and not for a last time. In 1936, his father killed himself. Daylong, nightlong disasters; drought, dust, business failure sapped pioneer energy. At eighteen, Smith, long before he could accurately define a failure in The American Dream, was haunted by its ghost in his own house. His father was dead. How? By whom? Why? When? Where? What does journalism fatten on? Murder and suicide. Naturally, local newspapers sniffed this small fact: the irrelevant, forgettable, expendable detail of some guy (named Smith?—not Jones, nor Brown). Why did a perfectly sensible man do a silly thing like that? Son, why did your daddy do it? He had so much to live for. Or did he?

Eugene Smith was educated early in a hatred of journalism, the apt shabby techniques of sob sister, feature writer, their colleagues with cameras, whose increasingly professional rape of privacy must dog Gene Smith for thirty years since he would, perforce, try to make a living beside them. But also art can be the prize snatched from such mortality as his father's. James Joyce fused fact with fiction in the context of Roman Catholicism in desuetude. Perhaps this doesn't apply to Kansas, but when young Stephen Dedalus, a rebel trembling on the threshold of art as a career, is taunted by his clever friend—Your mother's lousy dead and you wouldn't even pray for her—we hear an echo. What prayers prevail, Roman or Baptist? Your father is lousy dead; make something out of the lousy life which did him in. With a camera. I shall indict my father's murderer or fix the black magic of his, and my, self-murder. While newspapers, weeklies thrive by soiling us with their information, nevertheless, there must be a continuing dialogue. One must speak to another, many others—the world. Few are saints, martyrs, or artists. But let a working historian tell it how it was and is. "How could I remain to work in such a profession of dishonesty?" Thus demanded our indignant young Kansas Calvinist. Revenge murder by disdain? Avenge Daddy by silence. Not on your life. Life? (*Life?*) Smith was convinced by a friend on a newspaper that "honesty is not a profession. Honesty consists of what the individual brings to his work." Silence is golden, but the blank page tells no tale. So this naive postulant got himself a "photographic scholarship," created uniquely for him, at the University of Notre Dame.

In 1937, aged nineteen, he had enough of the strictures of disciplines which were then possibly more medieval than they might be today. Nevertheless he had been taught—and he learned. He came to New York to the big life. To *Life*, a weekly magazine, large format;

progressive pictorial journalism beckoned. When before in our civilization had the double page spread offered a surface so worthy of significant images? Shortly after, Smith joined the staff of *Newsweek*. *Life* had seemed too raw, too sensational, not in "good taste" to that class of luxury advertisers whom Henry Luce was astute enough to disdain. Luce, pioneer publisher, the smartest since William Randolph Hearst, let *Newsweek* glean those politer pastures of domesticated comestibility. *Newsweek* offered its readership a trace less rough, a bit more squeamish, smelling of that genuine gilt-edged American phony—Family Circulation.

In 1938, W. Eugene Smith was fired by *Newsweek*, which had its own morality, for Smith had done a bad thing. He had used a *miniature* camera. You don't use a small camera, boy, for a big magazine. Or at least a magazine bucking to be big as *Life* and twice as polite. You sell automobiles by the big sound the doors make when they bang, bigly, shut. That Big Door Sound. Apart from the elementary fact that small cameras can spy on or seduce those moments from history which *Newsweek* was eager to purvey, pictorial journalism as then practiced seems primitive now. Smith was broke; he free-lanced. He was soon offered permanent assignments. After all, he took pretty good pictures. But he preferred to risk starving than do hack work which only turned his stomach. He didn't exactly starve. He got jobs—from *Life*, from *Colliers*, *The New York Times*, *The American*. But now, oddly enough, he found the very use of his miniature camera hampering. Already it was a tool he had mastered. Hence he could discard it. He was becoming overly conscious of technique. He found himself getting dangerously artistic. There were problems: artificial light and a factitious employment of the multiple flash. Was he letting himself be victimized by that very freedom for which he'd fought?

In 1939, whichever muse it is that governs photography said: "Gene, you've been a good boy. You've used your eyes. You have fair eyes and a trigger finger. Rest them. Also, you have two ears. Listen. The measure of music is a means of dividing, marking, analysing—time. Music may whet your vision, which can be dulled. Gene, do thou *listen*."

What does music mean to most artists (*i.e.* visual or plastic practitioners performing today)? A few poets, composers, and dancers listen to records as if they were something more than a background for small talk, aural interior decoration, or an additive to drugs. That fancy hi-fi set, costing whatever its components cost, blasting away, wall-to-wall plush listening but not hearing; noise fused in flannel

non-music. Yeah, but the beat, man; the *beat*. Contrariwise, Smith took music as metric; its structure, its ambivalent syncopation, its return to order in opposition, its dialectical balance. Its very insistence, sharpened hand and eye. In 1939, he signed a retainer contract with what was then, after all (and all was quite a lot) and what is still, the most progressive mass-circulation weekly, *Life*.

In 1940, he married. A year later, impatient with the rut of assignments, he resigned his contract, attempting to find again some individual, idiosyncratic identity. It's hard working in a factory; it's doubtless hard even for the editors. Sometime, somewhere, there must be picture-editors with a sense of personal gift; sometime, somewhere, there seem to have been good prose-editors. Richard Garnett slaved for Joseph Conrad, whose native tongue was Polish; G. B. Shaw ill-advised T.E. Lawrence. The services of that editorial saint, Maxwell Perkins, are well-known. No one could ultimately salvage the mindless rhetoric of Thomas Wolfe, but Perkins was friend and collaborator of Scott Fitzgerald. Neither *Life* nor any of the other magazines have been often distinguished for comprehension or encouragement of mavericks like Smith. They are not patrons but publishers. It is naive to believe that they can be much more—same as Hollywood. However, in the hope that they might be, photographers are still encouraged to take good pictures, some of which get published. Choice or sequence are rarely those pleasing photographers. At this time, *Life*, jealous master and notable slave driver, naturally nettled by Smith's recalcitrance, warned him that if he was quixotic enough to throw up this contract, he could expect no further mercy from the Luce-machine.

But 1942 was wartime. Smith was in a position to elect his assignments. Now, thirty years later, he accuses himself of misusing his hard-earned liberty because of creative or rather moral immaturity. "I made . . . brash, dashing, 'interpretative' photographs which were overly clever and with too much technique . . . with great depth of field, very little depth of feeling, and with considerable 'success.' " Although these shots were conscientiously taken and analyzed to discover his own possibly unique service, they were still within the fairly strict limits of acceptable mass-media journalism. Yet he was always trying "to find himself." If this was vanity or dispersal of energy, while his considerable facility continued to make him feel somehow guilty, the problem of identity for commercial photographers remains: Who am I? Am I a photographer? Am I an historian? Am I an artist? Can I be used? To what limits do I pay for my use? Is my use, on any terms, always to be diluted?

Understanding so well the debasing mechanics of stop-press necessity, he managed to feel ashamed of work which later might have pleased him more. Such shame is either self-indulgence or the sole pay an artist-photographer or journalist-historian can award himself. In his own eyes, Smith repudiated his work; true, he had taken some fine pictures, but conditions prompting their taking were a violation of that luxurious qualification which for lack of a better definition he would always consider as freedom. To a man with a simpler soul, equable nature, or more modest energy, such a restriction might seem priggish and puritanical. Worse, eminently impractical. The few good pictures, or rather, the few pictures with which their taker was pleased, were paid for by endless ratiocination: dissatisfaction with those that hired him, with himself for letting himself be hired, with factors that forced the hiring.

Then, there was a real war, World War II, as distant today as the campaigns of Marlborough or Wellington. In between, there's been Korea: the immense obscenity of Vietnam. But World War II was, after all, not a phony war, but Hitler's war. And the Pacific— Pearl Harbor—Tarawa—Rabaul—Eniwetok—Iwo Jima. Gene Smith was invited to join Commander Edward Steichen's group of U.S. Navy photographers, but, apart from the fact Smith possessed no education (*i.e.* a parchment testifying four years attendance at an accredited college), he suffered from poor eyesight—also other physical lapses and a difficult character. Hence he was disqualified as "impossible" by the solemn idiots of the Navy, who debarred him from observing the death in battle of better educated boys.

However, fortunately, wars are worse run than *Time*, *Life*, or *Newsweek*. As fighting hots up, rules relax. In 1942-43, Smith found himself briefly as a war correspondent in the Atlantic theater, joining the staff of Ziff-Davis publications. He rejoined *Life* in 1944. Whatever else is said, *Life* made the best pictorial coverage of any wars within *its* life. Gene Smith saw the Pacific. He was party to many island invasions, on the unlucky thirteenth of which he was seriously wounded. "I would that my photographs might be, not the coverage of a news-event, but an indictment of war—the brutal corrupting viciousness of its doing to the minds and bodies of men; and that my photographs might be a powerful emotional catalyst to the reasoning which would help this vile and criminal stupidity from beginning again."

Herein lies the disarming failure in Smith's photography. He considers his pictures of Saipan and Iwo Jima failures. That is, he could

not show on a plain paper-surface coated with chemicals, in a snapped shot—the plump immediacy, savor of fright, grief, sadism, fun, and luck of war. Who can make an image to be saved from oblivion, emanating from a vivid orgy? Painter or photographer? Leonardo and Michelangelo failed to distill much tragedy in competitive patriotic cartoons celebrating a famous Florentine battle. They did display glorious gigantomachia, which long served as academies for the heroic male nude. What was war to them but a fair pretext to demonstrate the glory of athletic manhood?—Tragedy? Not remotely.—Heroic? Possibly theatrical; certainly beautiful and absorbingly interesting for technical virtuosity. Picasso's gigantically overestimated composition for which the bombing of Guernica was pretext is not tragic, nor exemplary (except plastically). It is an *entre'acte* curtain in tasteful *grisaille* for an unproduced ballet. Its graphic ingenuities have moved no one to tears—Picasso least of all. Now it has become merely a world-famous object, postcards of which are sacred souvenirs. That art is life, a substitute for life, or a program for living is a pious lie, perpetuated by museums of modern art, wherever they may be found. For men of lesser gift and greater guilt or stricter morality (like Gene Smith), battle is also a bloody game. But he was unable to spotlight it in an arcane proscenium or narcissistic sado-masochism on the level of an art-historical palimpsest. Smith, in spite of his skills and presence in thirteen assault landings, failed to capture that moment of truth in one of them, which rendered an image as memorable as Picasso's, although from his own words this seems to be what he was attempting. Woodrow Wilson did not make the world safe for democracy even by a first world war; Smith failed as has everyone else who attempts to make didactic art out of sudden death or mindless murder. Painters seldom have such ambitions; they are more preoccupied, modest, realistic in the matter of intellectual analysis. Smith differed from Picasso, and it was not only the difference between painter and photographer. Heroically, Smith with his meager equipment, a camera, lacked the tradition of structures of Western art, the services of post-Cubist analysis, the prestige of museum-culture, and an enormous visual ingenuity. He merely waited for invisible batteries masked by ragged palms to shoot the shit out of him and his friends as they hit the beach. Now he says he thinks this was a waste of time since marines are still getting shit shot out of them. I do not think his pictures from Iwo Jima and Saipan are negligible. Some of his shots, while they certainly prevent no future war, serve to remind us what this particular

war was like. They will serve as attractive footnotes to those overtidy histories which generalize war; they are miniature diamond-hard pebbles in a vast human mosaic.

Who needs such photographs? *Life* paid for them as it has tens of thousands of others. They were not particularly well-edited. Few felt Smith's shots were different in quality from many other reporters. But *Life* glamorized their daring representative and canonized him with a full-page portrait, his body completely swaddled in bandages. Given his ethic, naturally he was crushed by the inadequacy of his camera, his failure to capture what he'd actually lived. Smith failed as a philosopher, not as a photographer. No picture, however sadistic, pornographic, or aesthetic, starts or stops anything. Michelangelo's *Last Judgment* did not salvage the Judeo-Christian ethic. Mathew Brady hardly prevented another Gettysburg. Art has its place, proud or pitiful. Possibly photography is an art; at least photography is now more artful than most painting. The camera hasn't the potential for synthesis that has been demonstrated by digital mastery governed by visionaries in manual contact with stone, bronze, or paint. Photography is a branch of social science, if indeed there is such a measuring—and history. They may be the same thing. Certainly science and history employ artistic techniques. But contemporary obsession with the so-called creative act has swollen photography by idiotic snobbery which has the presumption, since both camera work and etching are classified in museums as graphics, to equate Rembrandt with Stieglitz and Goya with Brady. Greedy and pretentious print departments in our busier museums claim any image on paper as the equal of every or any other image on paper. This results in three generations of photographers whose activity is, from an aesthetic or qualitative judgement—nervous, compulsive, indiscriminate, self-imitative, mechanical, ingenious, and tiresome. It has stimulated curatorial energies; every print by everyone is an artifact, as significant as any Egyptian shard from some dubious and repetitive dynasty—significant only from the fact that it exists. Dominated by a condign conspiracy between mass media, coffee-table publishing, luxury-advertising, and competitive curators, photography since the Korean War has declined into ferocious overexposure. Possibly every click of every lens everywhere in the world would have a statistical significance were it reduced by computers to incidences of apathy and mindlessness on every map. Possibly there has been an advance in color, over-printing, tricks, and (ultimately) modest gimmicks. Photography has followed the example

of the tradition of automatic writing, the stream-of-consciousness used without consciousness or conscience. A quivering aura of tedium, the factitious prestige of the after-image hovers over most contemporary photography, which a caricaturist (like Max Beerbohm) could have penned: the ghost of Gertrude Stein, a stuttering mother-image presiding over the suicide of Ernest Hemingway, setting on his oft-wounded brow a bull-horned crown of thorns labelled "Success."

So for Gene Smith, his shots at Saipan and Iwo Jima failed. He condemns them; who with better right? Had it been left to me, I would have included very few others and quadrupled those admitted here. Anyway, he proceeded toward work that held greater personal satisfaction. He went through a lot more personal hell returning to work for the big-circulation magazines, where, in spite of everything, is the lone place professional photographers make a living. He was told he would have to prove anew his capacity to fulfill certain standards and requirements. Times had changed. New styles were needed. New styles of coverage. Life had to keep up with the times. *Life*. *The Times*. *Time*. The very quality or strength which had made Smith's name condemned him now to a file marked "Smith." A hospital is not the worst place in which to learn self-development. After several months spent thus from 1947, he emerged, healthier, to embark on a series of picture-essays that included "Folk Singers," "The Country Doctor," "Trial by Jury," "Hard Times on Broadway," "Life Without Germs," "Recording Artists," "Nurse Midwife," (the very famous) "Spanish Village," "The Reign of Chemistry," "Charlie Chaplin at Work," and "Man of Mercy" (Albert Schweitzer in Africa).

Samplings of these picture-essays are shown here. It's too bad they can't be seen on that scale for which they were first conceived. Those which have been chosen may be better printed than when they first appeared, but now they are very much smaller. Doubtless, their graphic or plastic values are closer to Smith's intention even reduced as they are. But the overall effect on the big pages, rough and grainy as the presses made them, loses immediacy. Only "The Country Doctor" retains full value in its generous pathos: that icon of exhaustion. For significant failures, since Smith seems to revel in his particular brand of unsuccess, I cite the essays on Charlie Chaplin and Albert Schweitzer—not pictorially, but for Smith a treatment of the mask of mortality. Here are two of our most charismatic archetypes, world-famous victims— seduced, corrupted, defamed, historically betrayed by mass cult, mass media, and a passionate lack of ironic historicity. Here is spelled

out, once and for all, that genius for didactic exploitation, the formula unconsciously following guidelines instituted by William Randolph Hearst, developed by Henry Luce. Supremely well stage-managed, reproduced, distributed, here is the rape of the innocent image.

Chaplin: greatest comedian of his time, casting himself as a failure through the confusion of compassion and irresponsible self-indulgence, corroborated by the publicity departments of the studio he almost knew enough to control, reduced to a grotesque expatriate basking in self-pity and a vacuous sunset. Schweitzer: in his youth, seeker of the "historical Jesus;" servant of Johann Sebastian Bach; traduced into a monster of self-indulgence; prey of an army of magnetized, voracious journalists, dedicated to perpetuating his ruthless paternalism and primitivistic methods. Schweitzer, framed in the persistent, picturesque atmosphere of an unchangeable jungle, administering homeopathic pity: retarded, retardative. No saint, but a powerful ego, vain as a movie star or canonized symphonic conductor, whose self-seduction was greased by every aid from *Life*, *Look*, *Paris Match*, *Der Stern*, and those other hundred eager scavengers. Squadrons of reporters sent out by the big weeklies served owners and publishers, who were also, and in fact, supporting Love, the core of the Judeo-Christian ethic, in its precipitate decline. Was it by accident Henry Luce was the child of missionaries to the (Buddhist) heathen? Did not the world still need saints and martyrs, if not canonized by a church in decline, at least self-elected and blessed by the chrism of publicity? Chaplin, the martyred exile; Schweitzer cast as Bach-Socrates-Jesus—could have, to the eye schooled in the irony of historical metaphor, been illuminated in the full aura of their metaphysical desperation. Instead, the compassionate camera man fell into the well-placed trap. Chaplin had not staged the greatest contemporary tragicomedies for nothing; he presented himself as he wished to be type-cast, with a minimum of make-up. Schweitzer was indeed theologian, organist, country doctor, missionary to the blacks; a sacred monster, in the line of freaks of dubious religiosity which stretches from the Abbé Liszt, through Richard Wagner to Billy Graham. And let us not, in any negative enthusiasm, condemn *Time*, *Life*, or *Fortune* for the rewards or opportunities they offer. Fame and adventure are paid for generously. Editors allocate no assignment to those unwilling. The trick is this (as all tricks of the devil are): to offer seemingly unlimited chances for capturing the sources of power (material or spiritual), and then due to circumstances beyond their control, to edit that very truth-telling essence right out of existence. The conditions of journalistic photography, its undivorceable

marriage to advertising, and the vacuity of public taste ensure this. And it is "beyond control" if you conduct mass media. Ultimately it is the photographer's choice, not his editor's. The Luce-machine is not the devil, not even today amid our general apathy. Less and less, defeated by a more powerful horror, T.V., is it The Enemy. But the wizard's promise of unlimited accessibility, with the fatal need to dull those edges a true poet must always require, corrodes any person confused in his gifts. Few survive such promises—journalist or historian, critic or photographer; everyone, including the readership, blames the machine rather than his own essential apathy.

This is by way of no judgment on W. Eugene Smith. Nor is it his biography. This is already too long an essay on why this book is a failure, why all such are bound to fail. A full account of Smith's life would be too painful to read or write.Few practitioners of his craft anywhere have survived his portions of personal misfortune, disaster, suffering. "Trying to keep going, to continue without turning from my photographic-journalistic stand, from those standards, those beliefs in photography *I would demand of no one else.** Trying to continue my own small kind of personal crusade which is many things beyond being a photographic photographer."

What was the epitaph over Fitzgerald's Gatsby? "The poor son of a bitch." What must be the epitaph of anyone who tries greatly and modestly fails? Nevertheless, I do not believe that Smith has lower standards for other men's work than for his own. If so, it is disquieting. Those who press beyond the tried analysis of their limits after a normal period of daring and enthusiasm waste themselves in repetitions of failure, trials which have not paid off, which will never be solved by reiterating formulae. Picasso boasts: "*Je ne cherche pas; je trouve.*" It can take a lifetime to recognize limits, but it is a waste of muscle if, through conscious suffering, one learns nothing but compassion. That, dictionaries say, means suffering *with* another: fellow-feeling, sympathy, pity inclining one to succumb or spare. Inflated images of belovéd pre-digested, tenderized popular types, not as they are in history, but as they are industriously blown up to be by an avid, avaricious permanent Present, feed on the reverse of Compassion, which is Self-Pity. To most, glancing through the pages of *Time* and *Life*, compassion means: I'm sorry for *me*.

Who has the right to make such drastic or dispassionate judgment? You don't hit a man when he's down. We live in terrible times. Gene Smith has been one of their more capacious witnesses. But, for the sake of argument,

*Author's italics.

and, since this is an essay about photography, may we not, indulging in the sport of analytical speculation, ask ourselves why this collection does not add up to more, and not alone this particular book? Why does every photographic book and almost every portfolio, however fairly edited or produced, amount to something less than one might have hoped from the energy, money, talent, technique expended? Photography, that is individual shots by professional photographers (films are something else), too often impresses us as delinquent craft.

Dr. William H. Sheldon, in his classic *Varieties of Delinquent Youth*, analyzes the problem, not—as does our dictionary—as neglect of duty (whose duty? judged by what or whom?), but as the failure to fulfill certain expectations which, governed by long attentive analysis, might lead to a belief in some inherent, specific, unexpected potential. Delinquency in art today is general; the history of twentieth-century painting, prose, and to a large degree poetry, a century from now will be less concerned with several isolated, memorable works, but rather with the exploitation and distribution of numerous momentarily negotiable personalities by casuistic mechanisms. Photography as an art form is a special case of delinquency. Much was expected; more came to be claimed. More was hoped from its putative services than any invention involving eye and finger since brush and chisel. It would surely replace painting; it only replaces portraiture and the battle picture. In our epoch, brush and chisel are judged officially obsolete. Instead, as franchise, we have drop, blot, splatter, or its reverse in hard-edged, paper-taped stencil; the ragpicker's bag, the junk-yard welder's torch. Metric in verse has been replaced by wan idiosyncratic "sensibility"; if a soul is sensitive, perforce his feeling is sincere, the feeling itself distinguished chiefly by the length of its typewritten line. The same follows equally for the structures or non-structures of aural mechanics in which melody has been outlawed along with verbal metric in a series of academic specifications which would have left Sir Joshua Reynolds breathless. Indeed the camera, quantitatively speaking, has been able to leave us more memorable images which stick in the increasingly unretentive eye than the dreary succes-sions of periods of a dozen modern painters, whose lively obsequies are regularly, efficiently, tidily, and fatally celebrated by accelerating series of retrospective shows at all those museums of modern art. Atget, Lartigue, Sander, Evans, Brassai, Strand, Caponigro, Gene Smith, or any personal favorite you nominate mean more, even in terms of plastic visual values, than the preponderance of painters, inflated past all limits in their vastly more pretentious and eager delinquency. But the potential of photography,

the parochial prestige of the photographer, has been outrageously shored up, past any early promise or eventual achievement, except in those realms of scientific measurement, where human eyes are physically incapable of penetrating. But, except for museum curators, scientific photographs do not share in the hierarchy of art, except by accident or ingenious manipulation.

Photography as science (including the landscape, as in the woodland and stream pictures of Caponigro), photography as history (as in the picture-essays of Gene Smith) is always youthful and attractive. But its unhappy flirtation with art depends on pretentious perfectionism, genteel embroidery. Imperialistic curators devoted to collection and classification are no friends to photography. They acquire samples, as if they were stamp collectors. Everyone must have his triangular Cape-of-Good-Hope, his surcharged U.S. penny (1871). Prints are filed alongside thousands of papery companions. Key photographers since the start were painters— Nadar, Steichen, Man Ray, Cartier-Bresson, Walker Evans—not great painters, but men comprehending the problems of rendering forms on a plane surface by hand and eye. Ancestral magicians (like Stieglitz, that Albert Schweitzer of photography) pushed the medium into a prestige of graphics past any real potential. From the ambitious areas they prophesied, on some level with Rembrandt or Goya, we cite its present delinquency: chiefly breasts and bellies, bumps and holes, hills and hollows at the disposal of Hugh Heffner and the photographic advance-guard of luxury advertising.

The dictionary defines pornography as *"The description of the life, manners, habits, etc. of prostitutes and their patrons; hence, the expression or suggestion of obscene or unchaste subjects in literature or art."* W. Eugene Smith is not a pornographer, but rather something more frightening and attuned to his time. He is a pornocratic photographer. The dictionary defines pornocracy as *"The dominating influence of whores. Specifically: the government of Rome during the first half of the tenth century."*

The photographer's service is not that of the lithographer, or etcher *manqúe*, or an embroiderer of trifling surfaces. His greatest service is the seizure of the metaphorical moment. History is constructed from documents; even the liveliest must be interpreted. This is not a task for him who first does the documenting. Documents testifying to the syntax of Cicero, the placement of caesurea in a line of Horace, the development of Marlowe's iambic pentameter, or the invention of an oil pigment capable of being stored in tin and hence portable are keys to history. It

is hardly by accident that W. Eugene Smith is a pornocratic historian. His times require him. As Rome approached the year 1,000, as we approach the year 2,000, worlds split. Byzantium had smashed the simple atomic unity of a Western civilized empire. (Barbarians were simply people who could not speak Greek.) What was promised to the people of Constantine's inheritance for a second millenium, since Jesus had signally failed to fulfill his absolute promise of love, forgiveness, peace, redemption, was a state in which assassination was the accepted policy of constant, instant *coups d'état*, where potential prime ministers were systematically castrated to ensure their clerical careers and soldiers were promptly blinded as reward for their service to the *basileus*. Imperial whores ruled from the Golden Horn. Naturally, the end of such a world was expected with some enthusiasm. The Eastern empire had endowed Rome with that shattering schism from which it never recovered. At the present, our pornocracy makes noises about an ecumenical theology in all the spasms of its senility, but this is more like an Appalachian conference of inefficient Mafia-types fending off untidy anarchy than real belief in any compassionate authority of a prince of peace.

It is to the world of 2,000 A.D. to which Gene Smith's pictures address themselves. They may have their small if solid use by that world then to show our world now. Brady for 1861-65, Atget for 1895-1910, Cartier-Bresson for 1935-70, Gene Smith roughly for the dates of this album. But Smith is different in kind; none of the others were hysterics. It is that element of controlled and sometimes uncontrolled hysteria which blesses Smith's best shots with aptness. Hysteria, the enemy of nihilism, a clean suggestion that things have gotten out of hand, smolders in Smith's most memorable prints. And, except for his war pictures, there is little enough violence; rather, a brooding calm before a presumed, inevitable explosion.

II. Autobiographical

I have a personal pornographic or pornocratic ancedote to tell about W. Eugene Smith, whom I met in 1940 and whose photographs I admired more than any American, save Brady, Walker Evans, and Alice Boughton.*

In 1942, I was about to go into the Army. I had a friend who shall be namelessly called Jerome Peters. He was a reporter for *Time*. He came to interview me about the ballet, a traditional form of virtuoso theatrical

*Illustrator of the great "New York" edition of the novels of Henry James, whose *Photographing the Famous* appeared in 1928.

dancing based on antique academic disciplines. He claimed he wished to know about the relevance of ballet in wartime. Could ballet be expected to survive with Western Civilization at stake? Could ballet withstand Hitler? How many homosexuals were there in my company? Would they claim draft-deferment? I asked him if he were referring to queens or dikes; if so, did that sincerely interest Henry Luce. Oh hell; you gotta get your story. This reporter had a sensitive approach; he had been to Cornell. He was sincerely (and he meant *sincerely*) interested in The Dance. So was I, and for lack of a better term we became "friends." Indeed I wanted a story in *Time* about male dancers. George Bernard Shaw, and Lenin before him, claimed an exemption of male performing artists from combat since their national service was in an exceptional virtuosity. So Jerry Peters and I became moderately intimate; we drank late. We didn't talk about the fucking war; we talked about fucking. He had a walk-up in Yorkville. One night I was inspired to outline a *Time*-style story with a switch which might get it past the Gossip Department editor. Ballet was skill, a metaphor for Freedom for which we were (almost) all fighting. Jerry was a little hysterical; when drunk, he got mean. He was pro-Nazi in his liberal-radical style; handsome and tubercular. Also crazy, in an uninteresting way. One thing he would not do was get himself drafted; sure his lungs were touched, but he wasn't sure how long this would stick for a 4-F disqualification. We indulged in one of those conversations about whether or not it was ultimately efficient to avoid the main, leading, or most significant events of one's epoch with lots of Jack Daniels. Finally he admitted he would tell 'em he was queer rather than get shot up in some idiotic war. He wanted to be a writer; he knew a lot about how *Time* worked; by God, after the war, or whenever, he was going to sit down and write *the* exposé of what shit *Time* really was. His rather small room had a door which ostensibly led to the john. He asked if I really *had* to go. I said I could piss out the window or didn't his can flush? Reluctantly he unlocked the door. What a relief! Suddenly, around the walls, I saw that they were completely papered with photographic proofs filched from Harry Luce's files. They were Gene Smith's shots of Pacific landings, recounting in detail the end of several young men 'neath frayed palms. Some were blurred, others clear; some had their typewritten labels still pasted on. Obviously they were pornographic; did Jerry sit there and amuse himself by shots of Tarawa? I came out of the closet and said something about Gene Smith being our contemporary Mathew Brady. He sighed: "Now you know. I can't take it. I'm scared. Did you *see* those pictures?"

"Yes," I said, "beautifully composed, like Rembrandt or Goya."

Jerry yelled: "You ignorant bastard; they're *real*." He was getting nervous; so was I. I said I assumed they were from a feature-film produced by Henry Luce. He yelled louder: "Now get out; if you tell anyone I'll kill myself." No need, for like one of those abrupt, untragic deaths in E. M. Forster's novels, T.B. took him two years later.

However, in his bathroom, before I'd ever seen a battle, I saw what Gene Smith had seen. A chapel for private devotions, creamy with guilt and fright, had emblazoned upon its walls some mini-pix Michelangelos. Gene had found and fixed one Last Judgment. Here was the pornography of murder—in which Jerry Peters had no share. Modest bacteria would claim him; until that moment he might dawdle on his can, confessing to gods of shame and death. Smith's icons were no palimpsest of tasteful torture. An historian had been sent to the Pacific by a commercial enterprise in the service of an imperialist power. He had taken his camera. He had seen stalwart, excellently trained and equipped boys atomized in an Eden-like landscape. He had recorded what he'd seen, not by accident, nor yet as a roving reporter, but with a nugget of grace allocated by some dispassionate godhead, who, disallowing compassion, unoccupied with salvage or salvation, whispered: "Gene, my servant, show it how it is."

Gene did. Maybe Jerry Peters, a penitent sinner of 1943, was partially pardoned by the recognition of truth in those extremities of action he was too lame to emulate, but who himself was also a forgiveable victim. Whatever Gene chooses to think of himself, it is not compassion residual in his photographs I most prize. In our day—since World War I, the Spanish War, World War II, Korea, Vietnam, the Middle East; the various ends of the Kennedy brothers, civil-rights workers, Black Panthers, Martin Luther King, and the many more murders about to break above us, an inevitable repression which will make McCarthy's inquisition look like a picnic—compassion won't mean any more: I'm sorry for me. I see Gene Smith's best photographs as icons, like those thank-you pictures painted by grateful craftsmen, set up as tokens before altars of their favorite name-saint intercessors, who saved their lives from tuberculosis, mad dogs, or an automobile accident. Without self-pity or vanity. Possibly hysterical. Possibly insane. Memorable.

Lincoln Kirstein

May 4, 1969

Bibliography

THIS BIBLIOGRAPHY is selective with the exception of that for *Life* 1938-1954, which includes picture essays, stories, and single photographs. Instead of a list of exhibitions, the bibliography of *Life* has been made comprehensive. Reprints of photographs by *Life*, particularly out of the context of the original essay or story, have been omitted. For *Life* entries after 1954 see the Photographs in Published Sources section. Single photographs which have been reproduced in various annuals, books, or magazines have been omitted unless they are previously unpublished. All entries under Publications contain written text, statements, or quoted remarks by the photographer.

Peter C. Bunnell

PUBLICATIONS

"After 7,500 Miles, a Wake," *Photography Workshop Number 3*, Fall, 1951, pp. 34-35. One photograph.

"Assignment in Studio 61/12 Photographs," *Photography Workshop Number 3*, Fall, 1951, pp. 28, 29, 42. Twenty-one photographs.

Chasin, Jo, and others. "Gene Smith Meeting," *Photo Notes*, November, 1947, pp. 9-11.

"Color/Be Exact As You Take It Mistakes Can't Be Changed Later," *Modern Photography*, 19:67-71, September, 1955.

Deschin, Jacob. "Serious Goals," *New York Times*, January 17, 1954. One photograph.

Eugene Smith Photography. Minneapolis, University of Minnesota, 1954. Reprinted in *Photographers on Photography*, Nathan Lyons, editor. Englewood Cliffs, Prentice-Hall, Inc., 1966, pp. 105-106.

Herwig, Ellis. "Inside W. Eugene Smith: A Teen-ager's Interview," *U.S. Camera*, 25:32, 86, 88, July, 1962.

Hicks, Wilson. *Words and Pictures*. New York, Harper and Brothers, 1952. Four photographs.

Hitachi Reminder. Tokyo, Hitachi, Ltd., 1961. Thirty-one photographs.

"How They Think About the Picture Story," *Popular Photography*, 44:50-53, June, 1959.

Images of War by Robert Capa. *Infinity*, 13:4-10, July, 1964. Book review.

Japan. A Chapter of Image. Tokyo, Hitachi, Ltd., 1963. With Carole Thomas. Poetic entries by Smith under pseudonym: Walter Trego. One hundred and forty-four photographs.

Letter to Shelley Mydans. *Time*, 46:11, July 2, 1945.

Maloney, Tom. "Wonderful Smith," *U.S. Camera*, 8:11-13, 46, August, 1945. Nine photographs.

"One Whom I Admire, Dorothea Lange (1895-1965)," *Popular Photography*, 58:86-88, February, 1966.

"A Personal Vision," *The Stars and Stripes*, 25:11, September 9, 1966. Four photographs.

"Photographic Journalism," *Photo Notes*, June, 1948, pp. 4-5. Reprinted in *1953 Universal Photo Almanac*. New York, Falk Publishing Co., 1952, pp. 19-28. Twelve photographs. Reprinted in *Photographers on Photography*, Nathan Lyons, editor. Englewood Cliffs, Prentice-Hall, Inc., 1966, pp. 103-105.

"Photographs and Truth," *Infinity*, 7:12, 13, 15, April, 1958. Three photographs.

"Photography Is a Potent Medium of Expression," *Creative Camera*, 55:32-33, January, 1969. One photograph.

"Photography Today," *Photography Annual 1954*. New York, Ziff-Davis Publishing Co., 1953, pp. 10-15. Four photographs.

The Photo Journalist. New York, The Fund for the Republic, 1959. Television interview, "The Press and the People 6," with Dan Weiner, moderated by Louis Lyons. Reprinted as "The Photojournalist," *Infinity*, 8:20-23, May, 1959.

"Picture Memo to the Editor on the New Leicaflex From W. Eugene Smith," *Popular Photography*, 56:52-53, April, 1964. Four photographs.

"Pittsburgh," *1959 Photography Annual*. New York, Ziff-Davis Publishing Co., 1958, pp. 96-133. Introduction by H.M. Kinzer. Eighty-nine photographs.

"Place Schweitzer, Africa," *ASMP Picture Annual*. New York, Simon and Schuster, 1957, pp. 6-11. Six photographs.

"A Spanish Village," *U.S. Camera Annual 1952*. New York, U.S. Camera Publishing Corp., 1951, pp. 149-159. Eight photographs.

U.S. Camera 1941. New York, U.S. Camera Publishing Corp., 1940, pp. 43, 73. One photograph.

U.S. Camera 1956. New York, U.S. Camera Publishing Corp., 1955, pp. 246-253. Eight photographs.

"A Walk Through A Paradise Garden," *U.S. Camera Annual 1947*. New York, U.S. Camera Publishing Corp., 1946, pp. 308-309. One photograph.

"The Walk to Paradise Garden," *Croton-Harmon News*, March 31, 1955, p. 3. Reprinted as "Walk to Paradise" in *Art and Artists*, Alfred Frankenstein, and others, editors. Berkeley, University of California Press, 1956, pp. 207-208. Two photographs. Reprinted in *Gentry*, Number 22, 1957, pp. 82-87.

"W. Eugene Smith Talks About Lighting," *Popular Photography*, 39:48-49, November, 1956. One photograph.

Whiting, John R. *Photography Is a Language*. Chicago, Ziff-Davis Publishing Co., 1946, pp. 136-137.

"The World's 10 Greatest Photographers," *Popular Photography*, 42:66, 84-85, May, 1958. Three photographs. Reprinted in *Photographers on Photography*, Nathan Lyons, editor. Englewood Cliffs, Prentice-Hall, Inc., 1966, p. 106.

ARTICLES AND REVIEWS

Chasin, Jo, and others. "Gene Smith Meeting," *Photo Notes*, November, 1947, pp. 9-11.

Deschin, Jacob. "A City's Portrait," *New York Times*, September 7, 1958. One photograph.

"Gene Smith in Japan," *Popular Photography*, 51:62-63, November, 1962.

Hicks, Wilson. *Words and Pictures*. New York, Harper and Brothers, 1952. Four photographs.

Judge, Jacquelyn. "W. Eugene Smith's Spain," *Modern Photography*, 15:78-87, December, 1951. Nine photographs.

Kinzer, H.M. "Shooting Without Stopping," *Popular Photography*, 57:46-49, August, 1965. Six photographs.

Kinzer, H.M. "W. Eugene Smith," *Popular Photography*, 56:74-79, February, 1965. Six photographs.

Lattes, Jean. "W. Eugene Smith," *Techniques Graphiques*, 58:123-137, Juillet/Août, 1965. Nine photographs.

Mack, Emily A. "The Myth Named Smith," *Camera 35*, 4:44-47, December/January, 1960. Three photographs.

Maloney, Tom, and others. "Wonderful Smith," *U.S. Camera*, 8:11-13, August, 1945. Nine photographs.

Mann, Margery. "Photography," *Artforum*, 5:67-68, March, 1967. One photograph.

Martin, Peter. "The Kid Who Lives Photography," *Popular Photography*, 13:19-22, July, 1943. Eight photographs.

Miki, Jun. "Eugene Smith," *Hitachi Reminder*. Tokyo, Hitachi Ltd., 1961. Variant reprinted as "Gene in Japan," *Age of Tomorrow 4*, February, 1962, pp. 12-14.

Neugass, Fritz. "W. Eugene Smith," *Camera*, 31:247, Juni/Juli, 1952. Three photographs.

Parrella, Lew. "W. Eugene Smith," *U.S. Camera 1956*. New York, U.S. Camera Publishing Corp., 1955, p. 239. Eight photographs.

Pierce, Bill. "W. Eugene Smith Teaches Photographic Responsibility," *Popular Photography*, 49:80-84, November, 1961.

Racanicchi, Piero. "W. Eugene Smith," *Critica e Storia della Fotografia*. Milano, Edizioni Tecniche, 1963. Fifteen photographs.

Robinson, Selma. "He Photographed the Real War," *PM*, May 26, 1946. Two photographs.

Tichenor, Jonathan. "U.S. Camera Achievement Awards Presented," *U.S. Camera*, 15:49-51, January, 1952.

Vestal, David. ". . . A Great Unknown Photographer— W. Eugene Smith," *Popular Photography*, 59:114-117, December, 1966.

"W. Eugene Smith," *Terre d'Images*, 7:3, Juillet, 1965. One photograph.

Whiting, John. "Camera on a Carrier," *Popular Photography*, 14:40-51, June, 1944. Nineteen photographs.

PHOTOGRAPHS IN PUBLISHED SOURCES

Canon Circle. Japan, Canon Club, No. 20, 1962. Eleven photographs.

"Colossus of the Orient," *Life*, 55:56a-63, August 30, 1963. Thirteen photographs.

"Drama Beneath a City Window," *Life*, 44:107-114, March 10, 1958. Fourteen photographs.

"The Endless Fascination of Water," *Sports Illustrated*, 9:34-37, September 1, 1958. Six photographs.

"From The George Eastman House Collection," *Nikkor Club*. Japan, 46, Autumn, 1968, p. 13. Three photographs.

Hospital for Special Surgery. New York, The Hospital for Special Surgery, 1966. With Carole Thomas. Thirty-five photographs.

Komura's Eye. Japan, 5, Summer, 1968. Three photographs.

"Ku Klux Klan," *The Second Coming Magazine*, 1:21-27, March, 1962. Seven photographs.

Lockwood, Lee (ed.). *Photographic Style*. Culpeper, Contemporary Photographer, 1963. Four photographs.

Lorant, Stefan. *Pittsburgh*. Garden City, Doubleday, 1964.

"Notable Modern Buildings," *Life*, 42:59-68, June 3, 1957. Eight photographs.

Photography Annual 1966. New York, Ziff-Davis Publishing Co., 1965, p. 126. One photograph.

Photography Annual 1967. New York, Ziff-Davis Publishing Co., 1966, p. 92. One photograph.

Photography Annual 1969. New York, Ziff-Davis Publishing Co., 1968, pp. 104-105. One photograph.

"The Power of Seeing," *Life*, 61:135, December 23, 1966. One photograph.

Reynolds, Charles. "Photographic Style," *Popular Photography*, 48:44, February, 1961. One photograph.

Saturday Review, 51:38-39, January 13, 1968. One photograph.

"35mm Portfolio," *U.S. Camera*, 19:44, September, 1956. One photograph.

U.S. Camera Annual 1940. New York, U.S. Camera Publishing Corp., 1939, p. 207. One photograph.

U.S. Camera 1942. New York, U.S. Camera Publishing Corp., 1941, pp. 120-121. Two photographs.

U.S. Camera 1950. New York, U.S. Camera Publishing Corp., 1949, p. 272. One photograph.

U.S. Camera 1954. New York, U.S. Camera Publishing Corp., 1953, pp. 232-235. Four photographs.

"W. Eugene Smith," *Camera*, 33:158-165, April, 1954. Eight photographs.

"W. Eugene Smith—A Portfolio," *Photography*, 10:40-43, June, 1955. Four photographs.

"W. Eugene Smith: An Exclusive Portfolio of His Unpublished Photographs," *Popular Photography*, 31:62-73, October, 1952. Eleven photographs.

"W. Eugene Smith: 12 Unpublished Photographs," *Photography Annual 1962*. New York, Ziff-Davis Publishing Co., 1961, pp. 76-87. Eleven photographs.

"Wind on My Wings," *Sports Illustrated*, 13:77-84, September 12, 1960. Six photographs.

PHOTOGRAPHS PUBLISHED IN *LIFE* 1938-1954

1938

"Old Age," 5:66, November 7, 1938. One photograph.

"Gas Masks," 5:57, December 19, 1938. Two photographs.

"Life Goes to a Rubber Ball," 5:56-58, December 26, 1938. Nine photographs.